Memory Art in the Contemporary World

Confronting Violence in the Global South

First published in 2022 by Lund Humphries

Lund Humphries
Huckletree Shoreditch
Alphabeta Building
18 Finsbury Square
London EC2A 1AH
UK

www.lundhumphries.com

Memory Art in the Contemporary World:
Confronting Violence in the Global South

ISBN	978-1-84822-422-3
eBook (Mobi)	978-1-84822-425-4
eBook (ePub)	978-1-84822-424-7
eBook (pdf)	978-1-84822-423-0

A Cataloguing-in-Publication record for this
book is available from the British Library

Copy edited by Michela Parkin
Designed by Wolfe Hall
Set in Mediaan by Dávid Molnár
and WH Aldine Mono by Wolfe Hall
Printed by Tallinna Raamatutrükikoda, Estonia

Memory Art in the Contemporary World

Confronting Violence in the Global South

Andreas Huyssen

NEW DIRECTIONS IN CONTEMPORARY ART

Series Editor: Marcus Verhagen, Senior Lecturer,
Sotheby's Institute of Art, London

A series of newly commissioned, engaging, critical
texts identifying key topics and trends in contemporary
art practice and discussing their impact on the
wider art world and beyond. The art world is changing
rapidly as artists avail themselves of new technologies,
travel ever more widely, reach out to new audiences
and tackle urgent issues, from climate change to mass
migration. The purpooc of the series is to discuss
these and other changes, in texts that are accessible,
stimulating and polemical.

INTERNATIONAL SERIES ADVISORY BOARD

Foreword

In a searing indictment of public attitudes to the Holocaust
in West Germany, philosopher Theodor Adorno wrote of
the 'atrophying' of 'the consciousness of historical continuity',
noting with revulsion that '[the] murdered are to be cheated
out of the single remaining thing that our powerlessness
can offer them: remembrance'.[1] Since 1959, when those words
were written, others have echoed Adorno, warning against
forgetfulness and calling for public attention to historical
trauma in particular. They have characterized remembrance
as a responsibility to the future as well as the past, to those
who will suffer if the lessons of the past are forgotten as well
as to those who run the risk of being 'cheated out of the single
remaining thing that our powerlessness can offer them'. But
remembrance is not in itself a tool for good. Many in history,
including the Nazis, have pressed for a return to origins,
glorying in a national past, often a sanitized, quasi-mythical
national history, perceived by them as the inheritance of some
and not others. The men and women who wrap themselves
up in confederate flags at Trump rallies, for instance, also
claim a vital connection to the past. Theirs is what Svetlana
Boym called 'restorative nostalgia'.[2] So while many agree
on the importance– the political significance – of collective
memory, what we remember is often a matter of fierce debate.

Equally contentious is how we remember. Public
monuments were for a time central catalysts and expressions
of collective remembrance, but today they tend to strike us as
signs of a mode of commemoration that has itself been forgotten.
In recent times, some monuments have illuminated competing
visions of the past when they have been torn down by
protesters. They have accrued historical meaning not through

but against the certainties they were intended to convey. And the debates that raged around the Vietnam Veterans Memorial in Washington DC and, more recently, around the Memorial to the Murdered Jews of Europe in Berlin show how little agreement there is around the forms and functions of the monument. But even as the rhetoric of the monument has come to seem problematic, artists around the world have considered historical trauma in urgent new terms, engaging with the mnemonic aims of the monument while dismantling its traditional forms and inventing new modes of address.

Andreas Huyssen's is a crucial voice in discussions of these practices of remembrance as they have emerged and developed in the period since Adorno delivered his lecture. In this book he advances his most sustained examination of those aesthetic practices yet, powerfully analyzing the works of a small number of artists, all from the Global South, who have reflected on political pasts that are not closed and finished but alive, painfully so, in the global present.

At a time when the promises of memory have faded, he finds transnational resonances in these works, which mobilize political and aesthetic experience to spark the imagination of an alternative future.

Marcus Verhagen

Introduction

孔隙度.

The world-wide memory boom of the 1990s centered on traumatic pasts was accompanied by a new understanding of the way memory works.[1] No longer a safe archival container of the past, as it had often been idealized, memory was now understood as fluid, riddled with forgetting, subject to an increasing porosity between past and present. The emerging field of memory studies began to focus on how memory and forgetting are indissolubly linked to each other, how memory is but another form of forgetting, and forgetting a form of hidden, evaded or ignored memory. Apart from the notorious unreliability of individual memory, it was recognized that in light of changing present-day realities, even collective pasts would alter their complexion over time. Social changes in the present put pressure on the ways in which various pasts are coded, reinterpreted and preserved in order to serve different political outcomes. Rather than being fixed in time and space, some pasts might shrink, while others would expand and proliferate in the course of time.

Any understanding of the past now had to be seen as subject to narrative and visual strategies of representation. Rather than safeguarding some stable past, memory became a site of political battles, conflictual memories replacing what used to be vaguely called collective memory. Given differing temporal layerings, memory struggles in one country learned from strategies used in another where debates were already more advanced. Thus Truth Commissions in South Africa and Chile took cues from Argentina, which in turn had learned from Germany's belated *Vergangenheitsaufarbeitung* (working through the past). Explicitly or not, the Holocaust, as the most

大屠杀.

researched and publicly discussed case of genocide, hovered in the background of all these memory debates.

The rise of memory art world-wide must be understood within this context. At stake was never only the historical past, but rather a living memory in the present that would prevent such political and racial violence in the future. Even if this hope has been disappointed time and again since the 1990s, it neither renders progressive memory politics useless nor their aesthetic expression pointless. This study explores how artistic practices in the visual arts and their supporting institutions helped generate critical insight and change perceptions of the past in public memory debates.[2] Beside artworks dealing with political violence, ethnic cleansing and genocide, there are memorials, monuments and museums problematizing social memories, all of which must be considered in an analysis of recent memory art and its political effects. Taken together, they have created a new venue for political art today. Much of this work was first generated around 20th-century catastrophes, primarily the Holocaust, with a focus on the limits of representation, but it soon spread to other historical events, where it raised complex issues of comparability and memory competitions.[3]

The new memory art emerged as part of an unprecedented concern with memory in the public sphere of a consumer culture involving far more than historical trauma. Slowly but surely, it spread across the world, resulting in the building of new museums, monuments and memorials, and affecting cultural production in many media at large. Retro, always at risk of nostalgia, became a key word in entertainment, fashions and architecture, replacing an earlier unconditional celebration of the new. In the decades after the 1990s, the internet and social media radically challenged traditional notions of temporality, experienced as linear sequence and based on the idea of progress. New forms of temporal and spatial perception emerged, transforming the status of the past in cultures of the present. As ever-more cultural materials from various pasts were sucked into a digital present by the force of algorithms and new media, the boundaries between past, present and

MEMORY ART IN THE CONTEMPORARY WORLD

future became increasingly porous. Accompanying the memory boom in the 1990s, the complaint took hold that contemporary consumer and media culture was simultaneously predicated on forgetting, fostering historical amnesia and political apathy. The dialectic of memory and forgetting took center stage. Obsessions with the past sit side by side with an increasingly flat present of the status quo – the great paradox of contemporary culture. Resistance to memory is ingrained in the structures of commodity culture, the internet and social media. Any Nietzschean celebration of forgetting is thus superfluous, if not insidious, at a time haunted by historical amnesia and a widespread illiteracy in matters of temporality and history. The abuse of memory by bad actors for political mythmaking must be confronted by more memory, not by forgetting.

Artists have used these confusions of temporality to create works that layer presences and absences, pasts and presents, the virtual and the real in subtle superimpositions and dissolves that require complex palimpsestic readings. Such aesthetic work, weaving a web of memories in the present with an opening to alternative futures, stands against an ever-growing tendency: the destruction of the human consciousness of being in time by the collective historical amnesia pervading the public spheres of our globalizing world.

Memory art is a vast field encompassing many different practices.[4] Rather than trying to write a survey, including memory art from the countries of the Northern Transatlantic and the post-Soviet world, I focus on a small group of compelling artists from India, South Africa and Latin America whose work I have followed since the mid-1990s. The argument in this book proceeds by way of a series of constellations of artworks from the Global South, which illuminate each other across different political and historical contexts. It thus differs from a monographic approach that discusses an individual artist's developments, guided by chronology and a conceptual frame.[5] It also cuts against any nationalist focus that would lay claim to some authentically unique national legacies. The dialogue of memory works that emerges in these pages reveals

aesthetic and political affinities as these artists negotiate their respective nations' traumatic experiences in relation to a transnational context. Key aspects of memory art are distilled in the aesthetic forms and media that these artists have chosen in order to inscribe their localized memory clusters into a global concern with human rights violations and political violence. The South-to-South axis of these juxtapositions is crossed by a North-to-South axis manifest in the ways these artists have drawn on the archive of Northern modernisms and postmodernisms, appropriating and counter-appropriating aesthetic techniques and rearticulating them from the perspective of the postcolony.

The range of their experiments reaches beyond national borders and limited time frames as part of the transnational dialogue on memory politics that emerged after the end of the Cold War. When the utopian energies of the 20th century – communism, fascism, modernization – had dimmed and increasingly revealed their horrendous cost, the anticipation of brighter futures was replaced by an accounting for the past as warning to the future. The slogan NEVER AGAIN emerged after the Holocaust, but it could mean different things in different parts of the world. In the Global South, memory politics castigated not only state violence, but it also stood against the frequent Western support of autocratic regimes and their embrace of neoliberalism. Memory's political contexts differed significantly: the end of military dictatorships in Latin America, the end of apartheid in South Africa and the resurging ethnic and religious violence in India, a legacy of the Partition. Increasingly, palimpsestic memory clusters emerged as societies trying to cope with their violent pasts learned from each other about truth commissions and trials, accountability and reconciliation. No wonder that artworks emerging from these different, yet comparable conditions reveal astonishing affinities that become visible in this book's constellations.

I focus on memory art from the Global South in light of the fact that the Southern hemisphere has seen dozens of wars, murderous civil conflicts, regimes of state terror and apartheid

during the decades of the Cold War and decolonization. While the US and France waged war in Southeast Asia, the French in North Africa, and Portugal in Angola and Mozambique, on its own territory the West enjoyed a period of unprecedented peace and the benefits of the post-World War II welfare state. In many cases, the violence is still much closer to home in the Global South today than it has ever been for most post-war European or North American citizens. This becomes clear as one looks at the multiple truth commissions in Latin America, Africa and South Asia, all of which are trying to find ways to remember and adjudicate violent pasts. While the political effectiveness of memory art is often put in doubt, it seems clear that it has more urgency in the Global South than it does in most Western societies. To be sure, with the renewed prominence of debates about slavery in the United States and colonialism in Europe, we have entered another stage of the memory debates. The Northern recognition of colonial violence marks another kind of *choc en retour* (backlash) than the one Aimé Césaire had in mind when he interpreted Nazism as the imposition of colonial practice on Europe itself. Nikole Hannah-Jones's *1619 Project* in the *New York Times* about the foundational nature of slavery for US history is as salient in this context as the recently contested debate about the relationship of the Holocaust to colonialism in Germany, or the European discussions of looted art. In the United States, the renewed debate about slavery is accompanied by a vibrant practice of African American memory art, for example in the work of Kara Walker or Mark Bradford. While this is clearly in tune with previous debates of political memory, it represents a radical expansion of the temporal and spatial frames of memory debates into a much deeper past, questioning the very foundations of Western civilization, its universalism, liberalism and democratic practices.

*

All the works analyzed in this book guard a certain autonomy and compel aesthetic experiences that transcend merely private

consumption or immediate and transparent public address. Their politics are not those of an activist art that is geared to direct intervention in the street, on the stage or in the public sphere at large.[7] These works have another temporality. They are activist, even avant-gardist, in a different sense as 'acts of memory', a term Doris Salcedo has used to describe her projects.[8] Rather than locking us into a past, acts of memory are of the present with an eye to the future. The artists discussed here no longer see their internationalism guaranteed by moving to Paris, New York or Berlin. It is significant that their work first became known beyond their places of origin via an evolving network of new biennales in the non-Western world, such as those of Havana, Istanbul and Johannesburg. Though they have become successful on the Western art market itself, their studios remain in their home countries and their work is grounded there – in Buenos Aires, Mumbai, Bogotá, Delhi, Johannesburg. Their goal is not to assimilate to the metropolis, but to remain local and differentiated without becoming 'national' in a political identitarian sense. By focusing on difficult and often repressed memories in their national contexts, their work fundamentally points to the failures rather than the successes of memory, but it is guided by the hope of mobilizing historical memory through affect and aesthetic experience to help us think about alternative futures. Their aesthetic is no longer wedded to radical notions of the unrepresentability of trauma, but still mindful of the thresholds of the sayable and the unsayable in representation.[9] The dual commitment to memories critical of national pasts and to a transnational memory politics is deeply inscribed in all of their works.

Memory art is in sync with the multidirectional and palimpsestic nature of memory in our world. In its movement beyond artistic and geographic borders, it is itself mindful of the disappearance and reappearance of borders and walls in an ever more connected world.[10] The works discussed ultimately refer the viewer to a postcolonial perspective on both Western and non-Western legacies. Creative engagement with aesthetic

practices in the countries of the Northern Transatlantic, far from pointing to merely derivative imitation, yield an oppositional stance vis-à-vis the confining forces of respective local traditions deemed authentic. The critical appropriation of Northern artistic practices in the memory art of the Global South should thus not be seen as a break with modernism, but as its radical transformation in the context of contemporary memory and human rights politics. This development could build on the fact that various politically inflected modernisms had already blended with aesthetic traditions specific to postcolonial societies in Latin America, South Africa and India.

The temporal dimension of the contemporary in memory art is not just the flat present without historical depth, the nightmare of an eternal consumerist now, as it is in much of the fare traded on the Western art markets. It is rather a contemporaneity seen and experienced in the conjuncture of two memory trajectories: that of creatively appropriated and transfigured elements of Northern art movements (expressionism, Soviet and Weimar avant-gardism, minimalism, installation art) and that of painful national and local memories of colonial oppression and postcolonial state terror and violence. Far from reducing art to the representation of past events, this memory-oriented work, whether consciously intended or not, is challenging its audiences to develop transnational solidarity and an imagination of alternative futures. Fully aware of its limited political effects, it is avant-gardist without the historical avant-garde's dream about changing the world through art, a dream that has lost the anticipatory power it had in the 1920s. But it does feed into national and transnational struggles for human rights in the face of a rising tide of 21st-century fascisms facilitated by finance capitalism's neo-liberal policies of dispossession and its ruinous effects on social cohesion. It operates with a notion of aesthetic autonomy different from that attacked by the historical avant-garde and by postmodernism. The autonomy of the artwork, indispensable to distinguish art from non-art, is now seen as always dialectical, embedded in processes of affective and cognitive exchange between the work

and its spectators. This is what gives new meaning to a key
argument in Theodor Adorno's *Aesthetic Theory* (1970), a work
situated at the cusp of classical Western modernism and what
came after.

✳

My readings of individual works are guided by the conviction
that historical political content and aesthetic form are consti-
tutively linked to each other. The form content takes in artworks
becomes the content of form itself. Adorno's *Aesthetic Theory*
offers a pithy formulation for this dialectic: 'Art's double
character as both autonomous and *fait social* [social fact] is
incessantly reproduced on the level of its autonomy.'[11] Social
reality and aesthetic form are always and inevitably linked
with each other, no matter how hermetic a work may be:
'The unsolved antagonisms of reality return in artworks
as immanent problems of form.'[12] Adorno's insistence on the
complexity of form in relation to the social world counters
the currently popular identity politics, which is a poor guide
to aesthetic judgment: 'Aesthetic identity seeks to aid the non-
identical, which in reality is repressed by reality's compulsion
to identity.'[13] These formulations, shaped by the context of
high modernism, fascism and Holocaust memory, are anything
but obsolete today. But they must be read against the grain of
Adorno's negative aesthetic, which privileged the trajectory
of a narrowly interpreted European modernism from Kafka
to Schönberg and Beckett.

I am aided in this project by Juliane Rebentisch's writing
about the *Entgrenzung der Künste* (boundary-crossing of the
arts) in recent decades.[14] Rebentisch starts from the crisis of
the medium-specific theories of art in the 1960s (Greenberg
and Adorno) and their overcoming as key to an understanding
of contemporary art. Adorno's late essay 'Art and the Arts' and
its notion of *Verfransung* or fraying of the arts marks the crisis
in theoretical thought.[15] But it also anticipates another more
expanded understanding of modernism/avant-gardism that was

to develop in subsequent decades. In the key chapter of *Theorien der Gegenwartskunst*, entitled 'Grenzgänge' (border walks), Rebentisch argues for an *Entgrenzung* of the modernist arts, a kind of critical boundary- and border-crossing that operates in medium-related, geographic-spatial and historical-temporal senses. At stake in this latest metamorphosis of modernism are the differences between art and non-art in visual culture, colonial history and its multiple modernisms beyond the confines of the Northern Transatlantic, and finally the political relationship to various, often traumatic pasts manifest in transnational memory art. I see such *Entgrenzungen* not as a break with modernism, but as a radicalization of an aesthetic modernity of an earlier period. They imply a critical negation of Eurocentric conventions and a displacement of aesthetic modernity to a different terrain, the terrain that modernism itself once had colonized. Coming as she does out of Frankfurt School aesthetic thought, Rebentisch acknowledges the inevitability of aesthetic semblance and the polyphonic transformations of aesthetic strategies bound up with the whole trajectory of modernisms across the world. Her main claim is that we should think of the *Entgrenzungen* of modern art in the contemporary world together with notions of the work as an open-ended process to be extended and contested in the aesthetic experience of its viewers. Aesthetic autonomy as a structural premise both in the creation and the reception of art is the dimension that distinguishes art from non-art as well as from agitprop.

To be sure, Adorno's late notion of a fraying or erosion of the separate arts acknowledged a growing porousness between traditional genres and media. Although he had recognized that 'today the only works that really count are those which are no longer works at all', thus criticizing the traditional quasi-religious notion of the self-sufficient and complete work of art, he remained tied to an idea of the autonomous modern work of art as monad.[16] Installation as form, however, linked to the notion of active and activating aesthetic experience, resists this very objectivist notion of the work of art. It expands the

modernist work into the spatial environment, which includes the spectator whose experience of the work becomes an element in its aesthetic effectiveness and interpretation. If art is to be effective as critique, it must develop dialectical strategies to draw spectators in through sensual aesthetic experience, which simultaneously demands reflection on how the construction of the work mediates knowledge about the world.

Memory art, with its strong reliance on formally mediated referentiality, requires that aesthetic theory and art criticism today rethink rather than abandon Adorno's dialectic of autonomy and *fait social*. Elsewhere in *Aesthetic Theory*, Adorno links art to the 'memory of accumulated suffering': 'All artworks ... bear witness that the world should be other than it is.'[17] Bearing witness to suffering, however, always includes an addressee. Rather than understanding the work of art as a closed monad to be contemplated from the outside, it is now to be understood as involving an open-ended process that operates between the work and its viewers. This process involves shock and seduction through stunning aesthetic forms; but it also demands heightened attentiveness and immersive contemplation, which challenges the viewer's apathy and enlightened false consciousness. The viewer's aesthetic experience of the work will always depend both on the work and on the socio-historical context of reception, which needs to be reflected in interpretation. The work not only embodies memory in its media and materiality, but it produces memory in the social present. The notion of *fait social* acknowledges not only the artwork's social genesis but also the historical and institutional contexts of its reception. The work's autonomy is not abandoned, but re-coded as a process triggered by the encounter of the work with its viewer. A more mediated notion of autonomy, key to an aesthetics of experience, is all the more indispensable since it alone can resist demands to adhere to hegemonic national traditions, political ideology or the rules of facile consumption.[18]

The notion of a socially mediated autonomy is paradigmatically expressed in memory art's installations and their intermedial, spatial and temporal expansion of artistic practices.

These installations are open to multiple genres like painting, sculpture and drawing as well as technical support systems like film, video, slide projection, animation and assemblies of objects. Installation art breaks not with autonomy per se, but only with traditional objectivist notions of the everlasting autonomous work of art and its individual genius creator. All installation art depends on multiple forms of collaboration. Artist studios become workshops, and the artist operates at least in part like a theater director. As memory art installations are often on display for a limited time only before they vanish, they acknowledge the transitoriness of both art and memory. The emphasis on the transitory is also manifest in the embrace of counter-monumental dimension shared by all the works discussed in this book.[19] At the same time, there is the great paradox that their counter-monumental vanishing generates intense curatorial and museal activities of documenting and preserving the traces of their previous existence – memory projects in their own right.

*

The first chapter of this book focuses on the empty bed, the solitary table, the empty chairs rendered in painting (Guillermo Kuitca) and sculpture (Doris Salcedo) – basic private and communal spaces, violated in times of state terror and civil war, sexual violence and forced disappearances in Latin America. The absence of the human figure, except in minimal traces, resonates with the logic of disappearance. No act of violence is ever shown. This kind of memory art acknowledges the risks and limits of representing violence. By preventing voyeurism and facile compassion, it challenges the imagination and cognition of the viewer, producing a simultaneously affective and intellectual charge characteristic of aesthetic experience.

Chapters 2 and 3 examine memory installations in gallery space and public urban space respectively, moving from specific instances of political violence in Colombia (Salcedo) and India (Vivan Sundaram) to a generic reflection on the progressive

course of imperial history from a South African perspective (William Kentridge). Some of the works discussed are indebted to a minimalist but affectively charged aesthetic of abstraction; others are exuberantly spectacular without falling for the spectacle's easy lure. Since the urban installations by Salcedo in Bogotá and Kentridge in Rome were only temporary, they themselves entered memory space after being dismantled or having faded from view. They not only transformed the imaginaries of specific urban sites but ignited a critical confrontation with difficult histories and their ignored, forgotten or evaded dimensions.

Chapter 4 on shadow plays is the conceptual core of the book. Nothing comes as close to the nature and functioning of memory itself as the elusive and yet representational shadow play. After all, it is light that creates shadows, just as lived reality creates memory in its shadowy aftermath. Enlightenment itself, as the 20th century has taught us, is rife with shadows and darkness. Human catastrophes, which developed in its wake, must be actively remembered, it is often thought, if a worse fate is to be avoided. Shadows thus operate in two registers, one real, the other imaginary: they mark the dark side of the dialectic of enlightenment in historical experience, and they embody the fragile legibility of the past in memory, which is always threatened by forgetting and erasure. Kentridge's shadow play is grounded in the animation of charcoal drawing while Nalini Malani's video shadow plays use colorfully painted Mylar cylinders in motion, combined with video projections. The very idea for this book's method of juxtapositions of artworks across cultures and geographies was born in my analysis of the shadow play in Malani and Kentridge's work. An earlier published version of this comparison actually led to a productive encounter between these two artists, documented in two public discussions about their work.[20] These discussions mark the dimensions of comparability and distinction in their respective use of the shadow play as a medium of memory.

While the first four chapters deal with cross-cultural affinities in the aesthetic treatment of difficult pasts, the final

three chapters focus increasingly on constellations of difference. Chapter 5 on 'Traveling Trauma Tropes' deals with two very different recyclings of Holocaust images and tropes in the work of Salcedo and Sundaram. It is well known that since the 1990s the Holocaust has provided a lens through which to look at other traumatic histories of political violence. Holocaust discourse has been used as a screen memory in the double sense of blocking out another memory (*Deckerinnerung* in Freud's sense) or, alternatively, of projecting the Holocaust onto the memory screen of other similar, but not identical historical phenomena.[21] It was precisely the emergence of the Holocaust as a universal trope that permitted Holocaust memory to be projected onto other episodes of genocide and political violence. In the transnational movement of memory discourses, the Holocaust, while not losing its quality as index of a singular historical event, began to function as a metaphor drawing public attention to other histories of political violence. Salcedo's subtle and poetic deployment of individual women's shoes as traces of absent bodies conjures up memories of the piles of victims' shoes in Holocaust photography and museum exhibits. Her work *Atrabiliarios*, however, emphasizes individual deaths rather than genocide. Sundaram's *12-Bed Ward* in turn inscribes the motif of shoes into the context of postcolonial dispossession and poverty in the Indian metropolis. Rather than focusing on genocidal violence, Sundaram's work draws attention to the slow violence of the neoliberal economic system that wreaks havoc not only in the Global South.

Chapter 6 reads two very distinct museum installations. They re-code Tate Modern in London (Salcedo) and the Victoria Memorial Hall in Kolkata (Sundaram), thus confronting both institutions with their colonial and postcolonial history. Any discussion of memory art would indeed remain deficient, were it not to include memory work in and on art institutions themselves, including critical transformations of existing museum space as well as novel memory museums. It is after all no coincidence that this age of memory and human rights has generated so many new museum buildings and museal projects.[22]

Chapter 7 compares the Santiago Museum of Memory and Human Rights with Salcedo's Fragmentos, a memorial art site that has begun to function as a museum, testifying to the dream of peace and non-violence in Colombia.

Having begun this book with art's treatment of intimate spaces of violence and disappearances, I end it in a suggestive coda with two works that treat time and space at the largest scale possible: William Kentridge's black box installation *The Refusal of Time* and Patricio Guzmán's film *Nostalgia for the Light*. Both embed their reflections on memory in science, respectively linking astronomy to Einsteinian physics and to archaeology, the exploration of deep time and deep space. Their focus on the relativity of time and space itself, both at the micro and macro levels, remains key to all critical memory art. This final reflection raises the difficult question of redemption through aesthetic experience: possible, but always fragile and fleeting. The memory artists discussed in this book mark the power of temporality in its past, present and future modes in human life. Faced with dystopian amnesia and a politically suffocating environment, 'acts of memory' can help us maintain perspective on lived time and on inhabited space. Call it redemption or not – like air, it is essential to keep us breathing.

Disappearances/Spaces of Violence: Kuitca's Painting and Salcedo's Sculpture

A comparison between Colombian artist Doris Salcedo (b.1958) and Argentinian Guillermo Kuitca (b.1961) seems counter-intuitive. Their differences in medium, aesthetic practice and political conviction about the role of art in society are simply too big. While both belong to the same generation of Latin American artists and began their careers in the early to mid-1980s, they work in fundamentally different media: Salcedo in sculpture and installation after training as a painter; Kuitca in a decisive return to painting after the Argentinian enchantment with Duchampism in the post-1960s. Their home countries share a history of state violence, but they have responded to it in quite different ways. Kuitca's work emerged at a time of extreme crisis in the year of the Malvinas (Falklands) War (1982), when the Argentinian military dictatorship was significantly weakened and its end could already be imagined, whereas the experience shaping Salcedo's early work was a highpoint of Colombian *violencia,* the attack of guerrilla forces on Bogotá's Palace of Justice and the ensuing massacre. Only Salcedo, however, became the artist fully and empathically engaged in memory art, while Kuitca's work relates to the Argentinian Dirty War in more indirect ways, which operate under the surface of his painterly project, the painting of space as subject to disintegration. And yet it is precisely the juxtaposition with

23

Salcedo's memory sculptures that permits us to shed light on Kuitca's hidden political beginnings, and on the ways in which the experiences of the Jewish diaspora and of the military dictatorship actually shaped his life-long obsession with securing spaces of refuge and stability in his painting.[1] Clearly, their different aesthetic handling of the political is grounded in the specific situations they were responding to. Kuitca reacted against the prevalence of explicitly political art in the Argentinian transition from dictatorship to democracy in the 1980s, whereas Salcedo reacted to the absence of public mourning regarding the ever mounting toll of Columbia's decades-long civil war. Salcedo's work, highly mediated through her meticulous work on materials, is always openly political in its references to the violence that has convulsed Colombia in waves ever since the late 1940s. The public invisibility of acts of violence itself is the mark of her aesthetic practice, which has violence as its theme. The call to collective and individual grieving for the victims of the civil war is embedded in aesthetic forms that require the viewer's sustained attention and extended contemplation of the work.

Guillermo Kuitca, by contrast, has mostly shied away from articulating any specific political message, except for one very early work of 1980 entitled *1–30000*. On a large canvas he inscribed numbers from 1 to 30,000 in tiny, densely packed handwriting, which if seen from a distance appears as a grey greenish monochromatic color field – the only direct reference in his work to the victims of Argentinian state terror. For many years thereafter, he has resisted political readings of his work. And yet, there is that series of paintings from 1982, *Nadie olvida nada* (Nobody Forgets Nothing), an incisive reflection on the effects of state terror, which I see as ground zero of his later trajectory. It was created at a time when he was enthusiastically caught up with the dance theater of Pina Bausch, which made him think that everything could be done in the theater and nothing in painting. With painting in an allegedly terminal crisis, this was his way to deal with the *Entgrenzung* of painting to other media, in his case the theater. The *Nadie olvida nada*

series was actually shown together with Kuitca's staged readings of a collage of texts by authors such as Juan Goytisolo and Elias Canetti. While that performance is not well documented, Kuitca recently put it this way: 'The painting series was like an exercise in constraint while the performance was a ground to upload all sorts of things with no other filter than the urgency.'[2] The urgency referred to the political situation of the Malvinas War and the anticipated fall of the military regime. It was the extreme pressure of the times, both political and aesthetic, that created the constellation of these early paintings and the theater, which in turn grounded the rebirth of painting in his career. The theater remained as a theme of painting in his work, not as an aesthetic practice of perform-ance. It was like a retraction of the abandonment of painting that had tempted him after experiencing the power of Pina Bausch's choreography.

Nadie olvida nada is a series of small minimalist paintings in acrylic on wooden boards or simple cardboard, most of them featuring a simply drawn empty bed with small, barely sketched human figures at some distance from the bed and seen only from behind. Bed and figures appear to be floating in empty space, some with intensely colored backgrounds in reds, yellows or browns. Perspective is limited to the shape and position of the bed. Otherwise, there is spatial limbo. The figures are marked as predominantly female. In one of the images, a woman is led away by two men in the painting's center, with other figures dispersed and forlorn in space and part of a bed emerging from a white-grey blotch of paint near the left margin (fig.1). In another, eight women all seen from behind appear lined up horizontally as if to be executed. They stand next to each other in the middle ground of the painting, arms and hands not visible from behind, with the uniformly yellow top garment between their black skirts and their black hair suggesting targets for an invisible firing squad. The series exudes a sense of alienation, placelessness and immutability. The small scale of the works, their somewhat unfinished look and the sketchy outlines of the figures betray a kind of

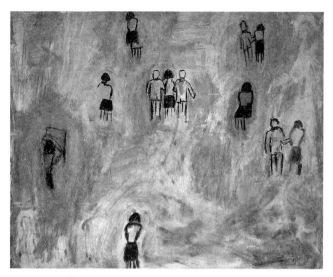

Fig.1 Guillermo Kuitca, *Nadie olvida nada*, 1982
Acrylic on wood, 122 × 154 cm (48 × 60 ⅝ in)
Private Collection, Buenos Aires

hesitation on the part of the artist to engage with the topic of
disappearances too directly. Kuitca approvingly cites a critic's
observation that these paintings looked as if they had come
about by the paintbrush being held still and the canvas itself
moving to produce the images.[3] I would read it as an écriture
automatique (automatic writing), executed under extreme
psychic pressure of a historical moment. And then there is the
single bed against a yellow background, painted on cardboard,
with its cover neatly at an angle leaving an opening for an
absent person to slip in (fig.2). As these paintings subtly but
unmistakably comment on each other, the spectator must ask:
What else is the empty bed than a bed emptied after its
occupant has been taken away and disappeared? After the state
has violently intruded on that most private and intimate space?
The multiple paintings of the series suggest traumatic repetition
precisely by their lack of spatial or temporal grounding.

 With its reference to forgetting and the visual presence
of empty beds and chairs, *Nadie olvida nada* assumes its

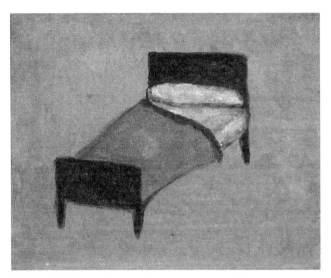

Fig.2 Guillermo Kuitca, *Nadie olvida nada*, 1982
Acrylic on canvas-covered hardboard, 24 × 30 cm (9 ½ × 11 ¾ in)
Collection of the artist

unmistakable political readability, especially if we juxtapose
it to Salcedo's sculptural treatment of domestic furniture in
works such as *Casa Viuda* (Widowed House, 1992–5) or *Unland*
(1995–8). My rather minimalist *point de départ* then is the mere
presence of chairs, beds and doors in their early work, which,
in both artists, is related to the violation of private intimate
space by the state's security forces or right-wing death squads.
But even here the differences are salient. There is something
tentative and delicate about Kuitca's *Nadie olvida nada* series
of 1982, whereas Salcedo's mutilated and concrete-filled
domestic furniture sculptures from the 1990s are barren and
even brutalist in their physical presence. Violence on humans
is differently conjured up without ever being shown by
either artist.

Perceived as the site of birth, sexuality and death, the
bed is key to any notion of privacy, intimacy and family life.
In a psychoanalytic reading, *Nadie olvida nada*, with its
double negative, diagrams a process of memory and repression

central to the Freudian understanding of traumatic memory. The 'absolute absorption'[4] Kuitca mentions as its origin is clearly significant. The series represents a veiled articulation of collective trauma and his own sense of vulnerability during his teenage years. The intensity of the historical moment, when the Mothers of the Plaza de Mayo were already marching, requesting information about their disappeared children, may have had something to do with the 'absolute concentration and the absolute commitment' that saw the series of paintings come to light.[5]

We need to ask further. Who might be the nobody of the title who forgets nothing? What is the nothing? What does the forgetting refer to? Clearly, taken together, the images of this series are marked by a resistance to forgetting the state terror perpetrated by the military dictatorship and its clandestine killing squads from 1976 to 1983. Instead of calling for commemoration in the spirit of the 1984 National Commission's report on the crimes of the regime entitled 'Nunca más' ('Never again'), Kuitca's title with its puzzling double negative poses a riddle that requires unpacking.

We know how dictatorship threatens private space, how people are pulled out of bed and arrested in their homes at night when they are most vulnerable. Salcedo's sculptures are marked by such violence, visible in their gouges and mutilations, but Kuitca's series gives no such clues. The 'nada' of the title captures the absence, the void into which the Argentinian *desaparecidos* have been thrust. Implied in the title by way of a third negation is the idea that everybody remembers everything. But Kuitca's phrasing recognizes the impossibility of such a remembering. After all, what happened to the *desaparecidos* in captivity cannot be remembered as long as it remains undocumented. This lack of knowledge is captured in the title with the word 'nada': if there is nothing specific to remember beyond the mere fact of disappearance, there will be nothing to forget. There is added significance to the fact that all figures in the series are drawn schematically from behind. The absence of faces points to the voiding of individuality by state terror.

And 'nadie' is not everyone remembering or forgetting, anyway. It is a figure of the void. The bodies represented in these paintings are the nobodies, barely visible in their contours, sometimes drawn in white, sometimes with simple lines in black, but always without individualized features. This is figuration at a degree zero, close enough to the total absence of figuration in the work of Salcedo. Trauma, as Freud knew and Kuitca shows, does not lend itself well to narration; nor can it be captured visually in figuration.

Ultimately the nobody of the title points to Kuitca himself, who is known for shunning self-expression. It is as if he hides behind the word 'nadie', just as Homer's Odysseus did when he faced the deadly threat of the one-eyed giant Polyphemus, giving his name as *udeis,* i.e. nobody, the better to escape from mythic fate. Analogously, Kuitca deploys the self-denial of *nadie* as a means of aesthetic and political self-preservation. By linguistically and pictorially wiping out subjective experience as well as empirical representation of the state terror, the objective space of memory is preserved all the better. This denial of self and subjectivity, present in a different form in Salcedo's work, stands in a long tradition from Franz Kafka to Samuel Beckett. Kuitca makes self-conscious use of this major trope of modernism, thus subtly giving shape to a very specific historical moment in Argentina – the anticipated end of the military dictatorship and its future in memory.

When asked in a later retrospective interview about the emergence of the bed as a leitmotiv in 1982, Kuitca said 'the bed became a refuge, a territory'. And then he went on to erase any overt political reading of the bed by reading it simply in terms of a space:

The bed now is a stage. On the surface of the bed you can trace a line. The bed becomes an apartment. The bed is land. The bed is a city. Ultimately the bed is theatre. At first the bed features in a big room, a large space with small objects. The bed becomes a way of setting the space.[6]

This indeed does describe the evolution of Kuitca's career as a painter from the 1982 beds via the *El mar dulce* (The Sweet Sea) series and the 'houseplans' (home as another place of refuge) to the disorienting maps, painted in acrylic onto mattresses, thus combining intimate place and extended abstract space (fig.3). The dialectic of the bed as a site of extreme vulnerability and as refuge is central to all of Kuitca's work. It sets the space he has explored as a painter.

The bed, the houseplan, the home as refuge point to another dimension of Kuitca's early work, that of the Jewish diaspora in exile, which merges with the precariousness of life under the dictatorship. Key here are several painterly references to the famous scene in Eisenstein's film *Battleship Potemkin* (1925) where an abandoned baby carriage rolls down the steps in the midst of the mayhem of the government's violent suppression of a strike. The filmed scene took place in Odessa, home of Kuitca's grandparents before they fled Russian pogroms and emigrated to Argentina.

Whether bed or baby carriage, it is always much more than just a setting of space. Given the continuing use of the bed as surface, later transformed into houseplan, or maps of cities and fictional countries, its emergence as a leitmotif highlights its role as refuge, and yet a potentially precarious and endangered space constitutive of Kuitca's overall painterly project. The bed became the basic model for all of his diagrams, which capture the visual world beyond figuration and beyond abstraction. Kuitca always refused to be called an 'abstractionist'. To him, diagrams are neither abstraction nor successful representation.[7] By side-stepping the discourse that pits abstraction against figuration, and visual presence of illusion versus its absence, Kuitca has successfully expanded the boundaries of painting itself. His work has created a new kind of image that remains representational in a non-mimetic mode, cool and yet sensual, geometric but delirious with color, conceptually rich but far from conceptualism in that it is still geared toward capturing modes of experiencing and knowing the world through painted images. His *point de départ* was remembering and forgetting

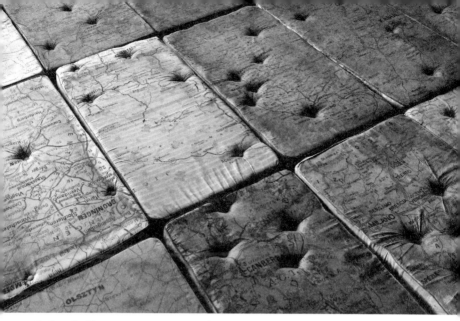

Fig.3 Guillermo Kuitca, *Le Sacre* (detail), 1992
Acrylic on 54 mattresses with wood and brass legs
each 120 × 60 × 20 cm (47 ¼ × 23 ⅝ × 7 ⅞ in)
The Museum of Fine Arts, Houston

the Argentinian military dictatorship and its victims. This constitutive moment went underground in his later work, just as even the minimalist figuration of the early series vanished after the *Siete Ultimas Canciones* (Seven Last Songs, 1986). Here we have an *Entgrenzung* of painting itself beyond figuration and beyond abstraction, centered in a representation of maps and diagrams, similar to Borges's writings, which secure a grammar of space rather than offering us a lexicon of spaces or a vocabulary of sites.

$*$

The presence of some human figuration in Kuitca's early painting distinguishes this work from the radical absence of the human form in all of Salcedo's sculptures, installations and performances. As space itself increasingly became the dominant theme of Kuitca's work, he also abandoned figuration altogether, however minimal and reduced it may have been in his early work. If Kuitca then became a painter of space, appropriating and spectacularly transforming the modernist tradition of the grid, the diagram, and the rational plan, space is also a major concern of Salcedo's work with sculpture and installation, though in a very different, somber and melancholy mode. Influenced during her studies in New York by Joseph Beuys's notion of social sculpture, space for her was always social space, a social space characterized by absences with minimal traces of the human, which is why, perhaps paradoxically, she describes her sculpture 'as a topography of life'.[8] Kuitca's painting also offers a topography of life, but in Salcedo's work the absence of human figuration remains indissolubly tied to the history of disappearances and the war on civilians. Yet both artists' work is energized by an 'anthropomorphic imagination'[9] of loss that intimates human presence through its very absence.

Upon her return to Colombia in 1985 from studying painting at New York University's art school, Salcedo witnessed the violent take-over of Bogotá's Palace of Justice by M19 guerrillas and the ensuing mayhem and massacre (see Chapter 3).

Arguably this was the political *point de départ* for Salcedo's early sculptural work. Her post-minimalist sculptures from the 1990s, as distant from modernist sculpture as from 1960s minimalism itself, consist of heavily worked, gouged and mutilated domestic furniture: wooden tables cut and jammed into each other (*Unland*); door frames welded to pieces of furniture (*Casa Viuda,* see Chapter 2); chairs, dressers and armoires filled with concrete and pierced by steel beams; wooden doors unhinged with pieces of bed frames protruding from them; a bed's headboard embedded in a concrete-filled armoire (*Untitled* series). Traces of violence such as human hair, bones, and torn pieces of clothing are often embedded almost imperceptibly in the concrete or the wood.

The considered absence of human figuration in these sculptures represents the absence of the disappeared; it also reflects the artist's conviction that showing violence on humans inevitably risks either voyeurism or facile compassion. It is a new take on the modernist belief that less is more. It was the latency and pervasiveness of political violence that she wanted to give sculptural form to. But it also suggests that Salcedo's main concern was the grief and mourning of lost lives. From around 1990, she pursued three trajectories of work simulta-neously. She carried out extensive detective work on crime scenes, first by collecting newspaper accounts of massacres and then by visiting crime scenes across Colombia; she also conducted substantive interviews with survivors of the violence, without ever making them public. Making survivors' grief her own, her empathy seemed to know no bounds. The artist functioned like a witness of the witness, a screen onto which the stories were written, but the stories were deliberately never told. At least not at first. Sometimes fragmentary remains from violent encounters, such as shoes or pieces of clothing, were incorporated in the sculptural installations. Any single sculpture condenses the grief of many survivors. The aim was to articulate experiences that went beyond single cases. Grief and mourning are indicated by the title of one major series of sculptures, *La Casa Viuda,* with its doubled meaning of the

widow's house and the widowed house. Focus is primarily on women, left in the wake of indiscriminate violence. The widowed house, present only in its violated fragments, is the house of *desaparecidos*, men, women and children, all victims of a seemingly endless conflagration. The sculptures imply the disappeared who lived with this furniture, gathered around the tables, slept in the beds, sat on the chairs, all of which have now become uninhabitable. Clearly, we are confronted with a kind of minimalist sculpture, but it is a minimalism of materials loaded up with a maximalism of affect, very different from the cool American minimalism of earlier decades.

If the precariousness of space was central to Kuitca's work, it becomes salient in Salcedo's *Unland,* an installation that consists of three tables exhibited together in a seemingly haphazard arrangement (fig.4). Their respective subtitles, *Irreversible Witness, Audible in the Mouth* and *The Orphan's Tunic*, pose riddles to the spectator. *The Orphan's Tunic* (1997) especially suggests how the sculptural object succeeds in affecting the spectators, entering into dialogue with them, making them thrice-removed witnesses while allowing for empathy and affect to grow in the process of experiencing the work.[10]

Unland – no mystery here – is the radical negation of land, the site of life and culture, community and nation. As a poetic neologism, it implicitly retracts the promises of its linguistic kin, Utopia, the no-place of an imagined alternative future. It is the land where normal life has become unlivable. Salcedo leaves no doubt as to the identity of this unland – Colombia. If such a reading of the work's title suggests a straightforward political artistic practice, nothing could be further from the truth. *The Orphan's Tunic* captures the viewer's imagination in its haunting visual and material presence, ultimately supported by this mysterious subtitle. The haunting effect is not present at first sight, as the viewer approaches what, from a distance, looks like a simple, unremarkable table with uneven surfaces, staged with those two others in a wide-open gallery space. It comes belatedly, *nachträglich* as Freud would put it, and it deepens as the viewer engages with the work from up close.

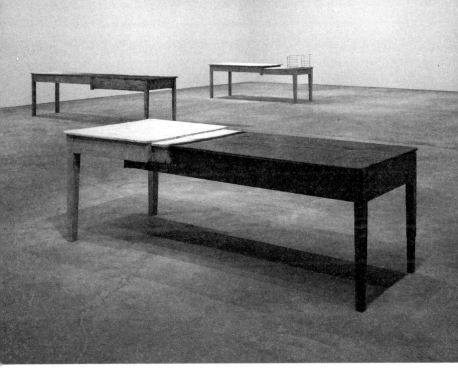

Fig.4 Doris Salcedo, *Unland: The Orphan's Tunic*, 1997
Installation view at SITE Santa Fe, 15 August–18 October 1988
Wood, cloth, hair and glue, 80 × 245 × 98 cm (31½ × 96 ½ × 38 ½ in)
Fundación "la Caixa", Barcelona

Its muted, but expressive power is such that it only grows slowly; it depends on duration, on sustained contemplation, on visual, linguistic and political associations woven together into a dense texture of understanding that implicates the viewer as witness of something unrepresentable and invisible at first sight.

If classical sculpture captures a salient moment from the flow of time, Salcedo's memory sculpture unlocks itself only within the flow of time. Temporality itself is inscribed into the work, which requires slow-paced reception. It dramatizes its materials, yet holds on to an emphatic notion of the artwork rather than dissolving it into performance. The objecthood of the work, however, does require the performance of the spectator who traces the expanded temporality of the sculpture, which itself, as object, embodies the process of memory.

The Orphan's Tunic is *objet trouvé* in a classical modernist sense, kitchen table, used and abused, material residue and witness. But if it is *objet trouvé*, it is so neither in the sense of Duchamp's as commodity object, nor in the sense of Beuys, whose use of materials like fat and felt was overloaded by alleged personal experiences in World War II. Simple and unassuming at first sight, Salcedo's table begins to come alive upon closer inspection. That which is *heimlich*, cozy and familiar, becomes *unheimlich*, uncanny, just as 'land' has become *Unland*. Up close, the spectator realizes that what looked like a table with different level surfaces is actually made up of two tables of different length, width and height, violently jammed into each other: the smaller, somewhat wider and higher table shining in a whitish, luminous grey; the longer table dark brown with blackened marks of heavy usage. Both tables are mutilated. Where they clash and are mounted into each other, the inner two sets of legs are broken off.

As the spectator's gaze scans the table, the whitish shine reveals itself to be a silk covering: the tunic, very thin natural silk that covers the surface, runs down the sideboards and wraps itself around the two legs. The silk is so thin that the eye is drawn to the cracks visible underneath, gaps between the five

wooden boards that make up the table's rough surface. The silk frays over the gap between the middle boards, intimating that the table might still expand, and it folds into some of the smaller cracks as if it were growing into them, attaching itself like a protective skin to the unevenness of the gouged wood. Examining this surface up close is like looking at the palm of one's hand with its lines and folds. There is a temptation to touch and to trace these lines. The effect is closeness and an almost tactile intimacy. At the same time there is a sense of fragility and vulnerability that contrasts with the sturdiness of the wooden table. Suddenly the table appears as a mute trace of something unspeakable, a trace that has been worked over by the artist in such a way that it yields its powerful affect.

Salcedo's work on the uncanny homeliness of the kitchen table is not tied to individual psychology, nor to a negative aesthetic of defamiliarization. Instead, Salcedo translates a national pathology of unspoken violence into a sculpture that articulates pain and defiance by bearing witness. She does so by opening the horizon toward literary language, a poem by Paul Celan, Holocaust survivor and poet always on the edge of the sayable. The orphan's tunic, key image of the poem, frays into the surface of the sculpture. As Salcedo tells it, the image she created with the table's surface translated the story of a six-year-old orphan girl, who had witnessed her mother being killed. Ever since that traumatic experience she had worn the same dress day after day, a dress her mother had made for her shortly before being killed: the dress as a marker of memory and a mute, but visible, sign of trauma. Though the story is not told by the work, when put together with Celan's poetic image, it helps us unlock the riddle of the subtitle. 'I do not illustrate testimonies,' Salcedo once said in an interview. 'I simply reveal – expose – an image. I use this word expose because it implies vulnerability.'[11] Expose images – this is precisely what Celan does in poetic language (fig.5).

Salcedo's documentary witnessing remains mute in the work; but once the language of the poem is brought to bear on our reading, the materials of the sculpture itself open up a temporal,

Fig.5 Doris Salcedo, *Unland: The Orphan's Tunic* (detail), 1997
Wood, cloth, hair and glue
80 × 245 × 98 cm (31 ½ × 96 ½ × 38 ½ in)
Fundación "la Caixa", Barcelona

though not narrative, dimension within the very spatial presence in front of the spectator. This double spatial and temporal effect is heightened when, looking even closer, one notices the thousands of miniscule holes, many of them a quarter or an eighth of an inch apart, with human hair threaded through them, going down into the wood, resurfacing and going in again. Hair of course is a residue of absent human bodies. But there is more to it than that. If the silk is marked from below by the unevenness and natural gaps in the wooden surface, it is marked from above by hundreds of hairs which look like small pencil marks, but actually hold the silk tunic close to the table. Now it is like looking at the back of a hand and noticing the short fine hair growing out of the skin.

If the tunic is like a skin, as Celan's poem suggests, then the table gains a metaphoric presence as body, no longer of an individual orphan but of an orphaned community, deprived of normal life. The wood of the table is solid, sturdy, a guarantor of stability. But the table itself has been mutilated. Not the least of the various mutilations are the thousands of holes drilled through the surface with a 1/64 inch drill-bit to permit the hair to be stitched through. The very idea of the painstaking labor involved gives one pause. What an utterly absurd activity, stitching hair, and lots of it, through a wooden surface. It certainly slows down time to a crawl. But perhaps it is also an act of mending? If the table stands allegorically for community, family, everyday life in its temporal extension, then the stitching of hair, inorganic trace of a human body, of the victim of violence, through the table's surface, is like the threading of pain and its memories through the surface of history. A pain that will remain without resolution.

As our gaze keeps moving slowly across the sculpture, its most stunning part is a thick band of hair that looks as if woven across the table just at the threshold between the silk tunic and the bare surface of the brown table. Here the tunic appears as though stitched down and held down, secured in place by the hair. Hair, skin, texture, body – all become legible in their contrast with the minimalism of the wooden furniture. It is

close to where the two tables are jammed into each other, close to where the four middle legs have been broken off, the threshold that makes the whole table structure look so vulnerable. Paradoxically this tenuous threshold seems fortified by the band of hair, densely woven from one side of the table to the other in a thick texture, an imaginative reversal of the basic nature of the materials. Stitching all this hair through thick wood suggests an air of defiance: it defies the implacability of the wood, but it also defies the absurdity and gratuitousness of violence in Colombia.

Like all of Salcedo's work, *The Orphan's Tunic* is about memory and unrelenting grief at the edge of a psychic abyss. It is about memory in the literal sense, both the content of specific memories of violent acts and memory as process and as structure, as the viewer takes up dialogue with the work. It is about memory in a spatial sense, approximating it, never quite getting to it, compelling the viewer to innervate something that remains elusive, absent – the violent death of the mother that left her daughter orphaned, the orphan present only in that residual tunic, which now seems more like a shroud covering part of the table. Forever absent are the communal or family events that took place around such tables, the chairs, the people, the food and drink served here. If the people, especially Colombia's Indigenous people, belong to the land, as Salcedo suggested in one of her interviews, then *Unland* marks the absence of the people from the communal site. It is a forced absence achieved through displacement and death. Far from suggesting merely a negative aesthetic, the piece transmits strong affect and empathy to the spectator who has to bring patience and time to engage with the work's objective expression of collective grief and loss.

Unland defies aestheticization, due to its use of simple everyday objects and materials. *The Orphan's Tunic* haunts us in its compelling beauty while at the same time evading any kind of voyeurism. Salcedo's sculpture moves the spectator to the edge of an abyss only thinly veiled by the beauty of the piece itself. The veil, however, is indispensable to allow us

to come face to face with the trauma and to become witnesses of a history we must not ignore.

＊

There is more to the juxtaposition of Kuitca and Salcedo than simply the emergence of the work out of national experiences of political violence. Both Kuitca and Salcedo, in a departure from the American postmodernism of the 1980s, value the autonomy of the artwork while not denying art's embeddedness in specific historical and social situations. Opposed to the subjectivity of much performance art, autobiography is barely visible in their work, even though that work emerged from similar experiences of political violence. The erasure of authorial subjectivity functions differently in their work. Salcedo's interviews with survivors of civil war violence in Colombia challenged her ability to be secondary witness to horrendous stories of terror. Her own emotional investment in grieving, which is a grieving of the witness for the bereaved and thus an example for potential collective grieving, is obvious whenever she speaks about her work. Aware of the resistance of trauma to narrativization, she holds that the individual cases of suffering must remain absent for the work to be. Some might reproach her for fetishizing the 'work', by keeping it free from documentary evidence. Others will acknowledge that her procedure guarantees the powerful affective dimension of the sculptures, which, in their abstraction from the empirical, avoid simple documentary evidence as much as the risk of voyeurism. She herself has recently relented on not sharing the stories for which she served as silent witness. She is now confident that each of her sculptures 'has a life of its own, that it is separate from the story that generated the piece'.[12]

Kuitca's erasure of authorial subjectivity and figuration in turn is as cool as can be, present in the neutral forms of dia-grams and maps, sometimes made up of bones or spines, but exploding in exuberant color schemes, especially in the paintings of disintegrating theater seating maps. And yet, his latest series of paintings, *The Family Idiot* (2018–19), with its

reference to Sartre's obsessive book about Flaubert, one of the founding writers of modernism, returns to his very beginnings with *Nadie olvida nada* and *El mar dulce*, but in a significantly darker hue. Tiny beds, chairs, and doors appear in large somber spaces in dark reds, greys and blacks, resembling stage settings. Disorienting segmentations of space, wall-size mirrors and bizarre thresholds give these paintings a nightmarish air, heightened by the dispersed and hard to discern objects, such as tape recorders, chairs, a microphone and empty beds. In recent years, Kuitca has muted his initial opposition to political readings of his early work, and one wonders to what extent this gloomy return to his beginnings may have to do with the waves of financial and political crises that Argentina has suffered over the past decades, crises which betray their origin in a violent and traumatic past that still leaves its imprint on the present.

Installation as Form: Sundaram's *Memorial* and Salcedo's *Casa Viuda* and *Untitled* series

India and Colombia both have histories of violent conflict going back to the Indian Partition of 1947 and, in Colombia, to the beginning of civil war in the late 1940s. Major artistic work on this violence emerged in both countries around 1990 with the installations of Vivan Sundaram (b.1943) and the sculptures of Doris Salcedo. I take these two artists – one from Latin America, the other from South Asia – to be paradigmatic for a major tendency in the memory art of the Global South. With their appropriation and *détournement* (defamiliarization) of Western aesthetic strategies, both modernist and postmodern, they have created a new form of political-aesthetic avant-gardism that has gained world-wide recognition.

The comparison between Salcedo and Sundaram begins with the story of a breakthrough: breakthrough from painting into installation in the case of Sundaram, and breakthrough from sculpture into installation in the case of Salcedo. Both artists were trained in those traditional media – Sundaram in the 1960s in Baroda and London, with time spent in Paris in 1968; Salcedo, 15 years younger than Sundaram, first in painting in Bogotá and then in sculpture in New York. Not coincidentally perhaps, both discovered the power of installation art more or less at the same time, around 1990,

when a new constellation of art and memory politics emerged across the world.

＊

While Sundaram began his career with painting in the context of Indian modernism, his 1993 *Memorial* marked his turn toward installation with visual resonances of Soviet construct-ivism, Arte Povera and a politically invested minimalism.[1] His move away from painting had already announced itself in the 1991 series of *Drawings in Engine Oil* and *Charcoal on Paper* produced in response to the first Gulf War. Works such as *Land Shift* or *100000 Sorties* consist of 12 large sheets of paper stitched together, which slide off the wall and continue onto the floor and into the gallery space. The drawings seem to represent aerial views of geological land formations filled with explosive dark markings, smudges, blurs and violent swirls, all of which suggest the devastations inflicted by the bombings on the landscape of Iraq. Dirty engine oil was displayed in small zinc trays on the horizontal part of the works on the gallery floor. Oil as geopolitical commodity replaced oil as used in traditional painting. As a painterly medium, oil suddenly seemed semiotically linked to the memory of colonial control. Clearly, Sundaram experienced 1991 as a key historical juncture. The Gulf War, the collapse of the Soviet Union and India's turn to neoliberal economics marked a major crisis moment not just in the Middle East, but for Indian secular democracy as well. Aesthetically, the engine oil paintings mark the urge to move toward a new medium. *Memorial* (1993) was the first major work in Sundaram's subsequent experimentation with multimedia, video, photography, sculpture and installation art, a trajectory of political art which never settled into some fixed and frozen style.

As a critical art installation rather than a traditional monument, *Memorial* was a first in modern Indian art. It was later reworked and expanded in 2014 to re-register its politically adversarial impetus: a complex work dealing with the upsurge

of violence against Muslims in 1992, triggered after Hindu mobs destroyed the Babri Masjid, a 16th-century mosque in the city of Ayodhya in Uttar Pradesh, allegedly built on a sacred Hindu site, the mythic birthplace of Hindu deity Rama. This event unleashed a wave of ethnic violence in Mumbai in 1992 that resonated strongly with the violence of the Partition itself. This foundational violence of the Indian and Pakistani states is fully remembered only now that the conflict between Hindus and Muslims has erupted again under the fundamentalist authoritarian Hindu regime of the BJP and its leader Narendra Modi. *Memorial* maintains its stature as a novel artistic intervention in the 1990s and a salient political protest then and now, when a populist Hindu war on minorities and democratic rights spells the end of the secular, multi-religious and multi-ethnic ideal of 'unity in diversity', the emblem of the Nehruvian state.

The inspiration for *Memorial* was a newspaper photograph of an anonymous Muslim man, lying slain in a Mumbai street in front of a toppled garbage container, clutching a small bundle of his possessions in the hollow of his beaten body. It was taken by photojournalist Hoshi Jal and published in the *Times of India* in January 1993. Art critic Geeta Kapur has compellingly described the photograph in its affective, political and aesthetic dimensions:

The contour of his side-long body is silhouetted against a toppled garbage-container that frames him like a stage-prop – a mini-tank with a rod sticking out – making the photograph's verity interpretable as (chance) construction. His profoundly still face with closed eyes is pressed close to the littered road. Here is the visage of death, death's becalmed face. Yet, he is marked by age, ethnicity, religion, class, and by the photographer-spectator's political understanding of fear narrativised within the frame of history. This is a classic image of the public victim: the mise-en-scène includes the detritus of street-rioting, the man's felled stance has the grace of a perfect performance. Except that this is not a performance; the man's image

is already conditioned by our trust in the *a priori*
'realism' of the photograph, by the photograph's technical
characteristic of capturing and certifying – he *was* present
/this *is* real.[2]

When I first saw Sundaram's installation in Mumbai in the
1990s, exhibited in the same working-class neighborhood
where this civilian had been killed, it felt like a counter-
monument, an elaborate cenotaph for an 'unknown victim'
embodying and anticipating the larger threat of political
violence tearing India apart. Displayed in a series of variants
later worked over by the artist, the photograph as belated
testimony of an event transformed the piece into a work of
anticipatory memory, not of documentation. The installation
treats mortality at the existential level of experience, which
is exposed as a public murder and embedded in an archive of
art-historical resonances, both of the Soviet avant-garde and
the American neo-avant-garde. We are in a memorial space
remembering both the recycled and repurposed ruins of
avant-gardism and the death of an unknown civilian, victim
of ethno-religious violence in Mumbai.

Sundaram had constructed a path for the visitors entering
Memorial through a barrier of minimalist-looking iron pipes
that served both as protective barrier and as threshold into
memorial space (fig.6). Viewers walked into the memorial on
a red sandstone pathway, itself reminiscent of Carl Andre's flat
geometric floor sculptures, toward a big arch at the other end of
the rectangular gallery space. Their move forward was blocked
by a triangular iron-frame-and-plate-glass *Mausoleum* whose
front marble slab wore an abstract inscription of diagonal and
curving lines reminiscent of both the style of the Suprematists
and of the abstract Indian artist Nasreen Mohamedi (1937–
1990). It seemed like a cenotaph honoring the memory of the
utopian Soviet avant-garde at a time when socialist utopian
thought had met its historical nadir. Inside the mausoleum
and protected by three glass walls was a life-size plaster cast
of a figure à la George Segal sleeping on his side and lit by

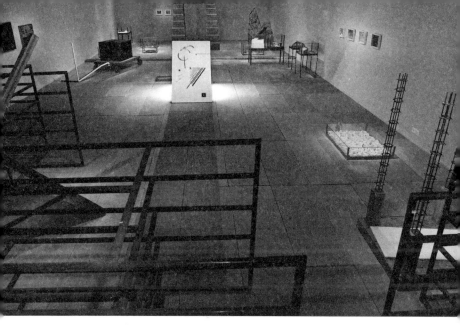

Fig.6 Vivan Sundaram, *Memorial*, 2014
Installation view, Kiran Nadar Museum of Art, New Delhi

Dan Flavin-like fluorescent light fixtures, a kind of replica of the victim's position on the newspaper photo. This part of the installation conjured up another set of art-historical reminiscences from the post-World War II American neo-avant-garde, having itself also become museal, if not 'mausoleal'. Following the pathway beyond the mausoleum, visitors encountered *Gateway*, an arch of stacked eight-foot-high, pink-brown tin trunks with an elongated coffin bridging the top. The structure resembled many an Indian memorial, though not in its poor materials connoting dispossession and death. And, finally, having passed through the gateway and turned around, the spectator looked up to the arch of *Gateway* and faced the open back of the elongated empty coffin, which displayed a text in blue neon light spelling 'fallen mortal'.

Dispersed to the left and right of the central pathway, visitors looked down into six small, glass-and-iron vitrines that sheltered or preserved the primary object of the instal-lation, the same photograph of the dead man recycled and worked over by the artist. Called *Burial*, they represent the emotive core of the installation. They suggest the traumatic impact the photograph had on the artist, palpable in its repetitive re-enactment. In one vitrine the body is framed by large nails, as if in martyrdom; in another the nails cover it up in an almost protective way (fig.7). In one image, a memorial wreath made up of nails envelops the torso of the fallen mortal. In another one, a half-transparent sheet of plastic covers the body like a shroud, pinned down by black tacks all around the image. Whatever the different use of nails may suggest, they always connote violence, including the violence of forgetting when they make the body disappear entirely.

This almost obsessive reiteration of the dead man's image testifies to the artist's deep empathy, which gives the victim his dignity as an individual. It is as if only here, rescued from the oblivion of a newspaper photo, could the victim find rest in burial. It is the artist who, in a kind of post-traumatic mimesis, creates a memory as burial site. The installation thus both asserts and transcends its documentary impetus

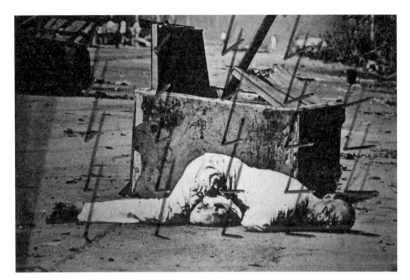

Fig.7 Vivan Sundaram, *'Slain Man' Memorial*
Installation, large nails grid, Kiran Nadar Museum of Art, New Delhi

into the realm of memory and empathy. The photograph itself in its multiple reiterations functions as the traumatic center of the installation, part of the installation that jumps out at the viewer, giving the image its affective power by both exposing and denying a one-dimensional mimetic referentiality. Realist referentiality and avant-garde abstraction are in dialectical tension in *Memorial*, nurturing the affective dimension of the work, which has not lost its power since 1993. The trauma of violence in the constitution of postcolonial India during the 1947 Partition – remembered, forgotten, erased – is syncopated with the violent mob riots of 1992, their repetition ten years later and their effects in the present as a permanent threat.

The fact that in 2014 Sundaram recreated this installation in an extended form for a retrospective show in Delhi only adds to the urgency of the protest, which the work embodies up to this day. It is still the multiplication of the original photograph and its heavily worked-over replicas in the vitrines on either side of the pathway that mark the distance of Sundaram's project from those of constructivism and minimalism embodied in the central axis of *Memorial*. The work differs from minimalist sculpture in that a real document, the photograph, is central to the installation; at the same time, Sundaram uses non-documentary aesthetic strategies to create an alternative view of the event that transcends both documentation and voyeuristic compassion. Remembrance and mourning are triggered by the dialectical juxtaposition of the photograph with found and constructed objects that blend distancing abstraction with immediate affect. In his 2014 expansion of *Memorial* with additional vitrines, Sundaram manipulated the original photograph digitally, so as to erase the human body either partially or totally. He thus drew attention to the fact that, with the passing of time, memory has turned into forgetting. The world has moved on. But the very practice of visible erasure here counteracts that forgetting. Visible erasure, after all, is a tell-tale sign of the very process of commemorating and forgetting, and it finds its correlate in the shadow

play practices of Nalini Malani and William Kentridge
(see Chapter 4).

<div align="center">✳</div>

Salcedo's embrace of installation as an art form happened less
abruptly than Sundaram's. Since sculpture is already a spatial
medium using real materials rather than representing them,
her move toward installation as spatial environment is not as
dramatic as Sundaram's move from painting to installation.
At the same time, her understanding of sculpture was radical:
in line with the critical postmodernism of the 1980s, she
rejected sculptural modernism and learned from the recoding
of sculpture in the European avant-garde and neo-avant-garde.
Thus Marcel Duchamp's *objet trouvé* as readymade and
Joseph Beuys's social sculpture merged to inform her early
experimentations with sculptural form. From her first works
in the late 1980s on, however, Salcedo's use of everyday objects
and materials differed from Duchamp's subversive playfulness
just as it stayed clear of Beuys's self-indulgent political
activism. The pain caused by the Colombian violence, which
had once again come to a head in the 1980s, was front and
center in her deployment of readymades and their material
transformation.

Her practice of installation art emerged from the assemblage
of several sculptures in exhibitions, paradigmatically in one
of her first solo shows at Bogotá's Galería Garcés-Velásquez in
1990. In *Untitled* she placed gridded steel bedframes, discarded
from hospitals, either horizontally or leaning upright against
the gallery wall, combining them with another untitled series,
stacks of varying heights of folded, pressed and starched white
shirts impaled on tall metal spikes. Some of the bed grids were
wrapped or even extended with animal skin, as if to suggest
broken limbs and a bandaging of wounds, clearly a gesture
toward Beuys, but here evoking political violence rather than
personal mythmaking. Both the discarded bedframes and
the stacked pierced shirts echo the absence of human bodies.

The violence conjured up with this installation is more direct than in many of Salcedo's later works. We know that the work was compelled by her research into the 1988 targeted massacre of some 20 members of the banana workers' union at the La Negra and La Honduras plantations. The bedframes suggest links to Kuitca's mattresses (see Chapter 1), which evoke diasporic displacement, and to Sundaram's *12 Bed Ward* (see Chapter 5), which echoes the slow violence of metropolitan poverty and dispossession. Different from the mostly generic use of the bed and its multiple functions in European and North American art (Anselm Kiefer, Michelangelo Pistoletto, Robert Rauschenberg, Rachel Whiteread), political violence is inscribed in these works by artists from the Global South.

The works that grounded Salcedo's international reputation were the two furniture series of the 1990s, *Casa Viuda I–V* and *Untitled*, as well as the three tables of *Unland* (see Chapter 1). As with Sundaram's serially reworked photograph in *Memorial*, Salcedo's multiple reenactments of violated living space mimetically reflect a kind of secondary trauma of belated witnessing. Visible are only the effects of violence, not the violence itself. But these effects are objectified in the sculptures with an almost compulsive intensity of empathy for the displacement of the survivors. The affective charge of these works arises from objects in space rather than from a representation of human subjects.[3] However carefully individual pieces may have been positioned in gallery space, these early assemblages still maintain the sense of temporary juxtapositions of individual sculptures even if the empty space between them, the space of circulation of the viewer, was carefully calculated to challenge and disorient the viewpoint, the movement and the implication of the viewer in post-traumatic experience.

The *Casa Viuda* (Widowed House) series (1992–5) anthropomorphizes the house itself as widowed and grieving. Unhinged and strangely elongated doors are combined with dislocated and equally dysfunctional pieces of furniture. In *Casa Viuda I*, a door stands flush against a wall. It leads nowhere (fig.8). As if that were not enough, its bottom is blocked in front by

Fig.8 Doris Salcedo
La Casa Viuda I, 1992–4
Wood and fabric
257.8 × 38.7 × 59.7 cm
(101 ½ × 15 ¼ × 23 ½ in)
Private Collection

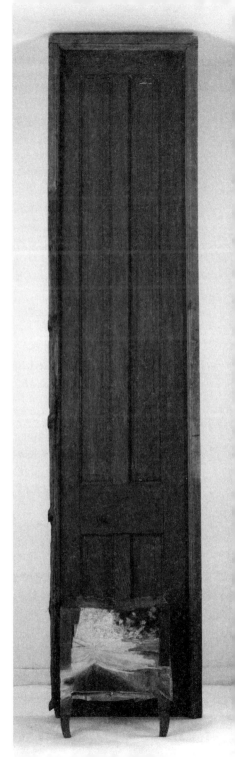

INSTALLATION AS FORM

a small chair whose back seems to have been disappeared into the door. The curved front feet of the chair are outwardly turned by 90 degrees, giving the chair a precarious look as if it were balancing on tippy toes. A bluish-white lace skirt is trapped between chair and door. It is wrapped tightly around the front legs of the chair, which now insinuate the legs of a violated woman. The door blocks a view onto what happened. But the chair with its skirt and the forced twist of the legs suggests that which is not represented (fig.9).

A trace of human clothing is also embedded in *Casa Viuda II*. Here it is a half-open zipper running down the middle plank of a wooden chest attached not to the front, but to the back, of a tall door. If standing straight in front of the door, one may wonder what view it is blocking. If standing to the side, one sees this chest blocking the space behind the door. Again, any passage through the door is closed off in either direction. Zooming in on the piece one notices not only the zipper forced into the wood, but also a number of small white buttons as well as a bleached splinter-like bone wedged into the seam between two boards on the chest's surface.

The inclusion of such traces of the human is a technique Salcedo uses in many of her uncanny furniture pieces. Critics have spoken of anthropomorphized sculpture, but rather than life, these residues evoke death, violence, disappearance of the human. This is also what the title *Casa Viuda* connotes. As opposed to the absence of the human itself in these sculptures, it is very much present in *Casa Viuda III*, which places the viewer into the very space that the sculpture defines as uninhabitable. In a narrow passage, a bed's headboard is positioned against the wall while the footboard is placed against the opposing wall. Visitors suddenly find themselves in the space of the empty bed, a strategy to evoke a mimetic relationship to the disappeared and to the uninhabitable space conjured up.

The second major series of the 1990s is called *Untitled*, pointing to the disappearance of a title and the precariousness of naming. In the context of violent disappearances, the title

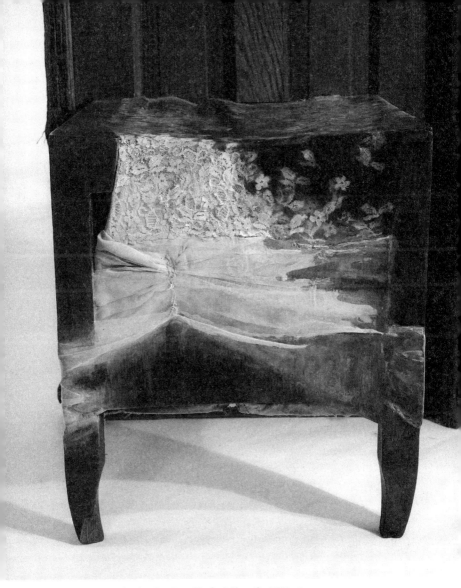

Fig.9 Doris Salcedo, *La Casa Viuda I* (detail), 1992–4

of the series thus assumes a meaning different from that of other untitled artworks. The series still has close affinities to *Casa Viuda*, though its emphasis is different. Dysfunction, immobility and the oppressive thickening of time in the aftermath of the experience of violence characterize both series. But immobility is exacerbated here by the massive use of concrete supported by steel rods and poured into the cavities of chests and large armoires, and onto the seats of chairs. While *Casa Viuda*, with its traces of the human, still points to acts of domestic violation and victimization, *Untitled* shifts the focus to the weight and heavy burden of traumatic events that have made living space uninhabitable. The grey concrete mutes and deadens the language of the wooden furniture, and where the wood with its warm colors still shows, it is often covered by smudges of grey cement. The work puts the emphasis on the durational after-effects of traumatic violence, which muffle and silence the pain of survivors by their sheer weight. Salcedo's use of concrete to allegorize the burden of past experience resonates with the work of William Kentridge, who spoke of apartheid as the rock, immovable and always present in memory (see Chapter 4).

If the assemblage of the series in a gallery may strike the viewer as a furniture warehouse in disorder, the visitor walking among the pieces will enter into a slow rhythm of looking and walking, taking in different perspectives, looking from a distance and looking up close. The exhibition space creates room for thought and for memory. In one piece, a large armoire, its open spaces partially filled with concrete, rises from inside the headboard of an empty bedframe. Crumpled shirts and other pieces of clothing are buried in the concrete, making them just barely visible. In this context, such residue of human clothing points to the fact that the clothes of the departed often provide an emotional link to the dead. Ossified in the concrete and frozen in time, however, even such memory has been deprived of its life-enhancing power. Ever since Dürer's famous and mysterious engraving *Melencolia I* of 1514, immobility and the arrest of time have been understood as a sign of melancholy,

with modern trauma as perhaps its most extreme form. The compulsive reenactment of traumatic memories does not allow either for an exit or for a working through of the past. The series as a common form of artistic expression takes on its specific meaning in Salcedo's work of the 1990s: it reflects on the compulsive repetition of trauma in sculptural form. The mimetic affinity of the artist to surviving victims of violence is evident in the intensity with which Salcedo has produced sculpture after sculpture in the 1990s, propelled from one version of *Casa Viuda* and *Untitled* to the next.

At the same time, the juxtapositions of these works in gallery or museum shows are always more than mere assemblages, stand-ins for the compulsive repetition of traumatic memories. They cohere both at the conceptual and at the visual level. For Salcedo, similarly to Kuitca, 'space is not simply a setting, it is what makes life possible'.[4] When living space is violated by terror and war, sculpture as a spatial art bears a heavy responsibility. It must address the 'issue of uninhabitable space'.[5] With its doors that lead nowhere, its armoires filled with concrete, its chairs no one can sit on, its mutilated tables and its empty bedframes lacking a surface to sleep on, the furniture series of the 1990s highlight the impossibility of habitation. It is not the loss of home in exile, as it is conveyed in Kuitca's diasporic mattresses. It is rather the destruction of the very possibility of habitation by the violence suffered at its core. Salcedo's main subject is not the act of violence itself, but its deadening effect on the survivors who 'enclose themselves in complete – mute – silence'.[6]

Stunned silence has also often been the reaction of visitors to Salcedo's furniture sculptures. Silence that only slowly leads to recognition on close examination of the pieces and insight into a past they evoke. In her words: 'Memory must work between the figure of the one that has died and the life disfigured by the death.'[7] That in-between space is precisely what the furniture sculptures conjure up: the violence is there in the way the pieces have been violated, mutilated and worked over by the artist, while the victim of violence is absent. Disfigured and

displaced lives are present in the ways the pieces of furniture have become uninhabitable. The memory that emerges is a memory of pain, and Salcedo's sculptures give silent voice to this memory. As the witness of witnesses of violence, who are not publicly heard in Colombia, Salcedo has created memory works that themselves hope to create a public memory in their own muted and effective way. They emerged from the failure of Colombian society to remember, its failure to grieve the victims and their survivors. But they acknowledge that, as Luis Buñuel once said, 'life without memory is no life at all ... Without it, we are nothing.'[8] Whether or not these sculptures have helped victims of violence to find inhabitable space again and to live with their memories of pain is a question hard to answer empirically. One recent work by Salcedo, Fragmentos, a public, even official, counter-monument to the civil war and proof of the possibility of peace, has given a resounding yes to that question (see Chapter 7).

Installation in Urban Space: Salcedo, *Noviembre 6 y 7*, and Kentridge, *Triumphs and Laments*

Since the French Revolution, the notion of public art has lived off its contrast with the private collection. It covers many different media, a variety of publicly accessible sites and multiple forms of public funding. Recent decades have seen the emergence of new varieties of public art across the world. State or city funded or privately financed, commissioned or spontaneous, bureaucratically permitted or illegally executed in urban space – new forms of public art have emerged from the post-1960s impetus to democratize the reception of art, to create new experiences of art affecting the relationship between art object and recipient, to articulate political protest, but also to make city life attractive for its citizens and to produce a kind of cultural imagineering to attract tourists, business and global fame.

Especially with the *Entgrenzung* of painting or sculpture into installation art, a new space for the encounter between spectator and artwork has been created, one that no longer depends on the fixed position of the work and of the spectator frozen in quiet contemplation. Installations gain their power in the viewer's experience of moving around in them, getting close and distancing oneself again, becoming part of a spatial environment in motion. Just as the spatial dimension has been set in motion, the temporal dimension is equally mobile.

In the wake of such developments, there are new forms of public art including performances, temporary installations and spectacular events, which differ from earlier public art embodied in permanent fixtures such as public monuments or murals. At any rate, the boundary between museum art and art in public space has become porous.

Commemoration of the past has of course always infused public art. Celebratory statues and monuments dedicated to major events and public figures stand side by side with monuments and memorials to the fallen in war. Public art thus negotiates human history: it preserves memories, celebrates or criticizes power and mourns the dead. But those older static forms of public art – the monument, the mural fresco, the memorial – have been set in motion in contemporary installation practices.

At a time when memory art has emerged as a major dimension of the contemporary art scene worldwide, it is no surprise that public art deals increasingly with issues of memory and temporality. I will focus here on certain forms of installation art that take installation from gallery or museum space out into site-specific urban space. The pertinent work of Doris Salcedo and William Kentridge, different as it may be in its aesthetic strategies and materials used, gives us examples of how an art form meant for the museum can bleed into public urban space.

I will juxtapose Doris Salcedo's *Noviembre 6 y 7*, her work of 2002 on the 1985 guerrilla take-over of Bogotá's Palace of Justice, which did more than merely commemorate a major massacre that 17 years later still awaited a full explanation, with William Kentridge's spectacular and deeply melancholic Roman history mural, *Triumphs and Laments: Project for the City of Rome* (2016), on the banks of the Tiber.

*

On 6 November 1985 at 11:35 am, a group of 47 M19 Guerrillas burst into Bogotá's Palace of Justice, seat of the Colombian Supreme Court, which, on that very day, was to decide on an

extradition treaty with the United States regarding 'narco' leaders. Just 53 hours later, after an all-out attack by the army on the palace, 11 magistrates and 101 others – guerrillas, soldiers, civilians – were dead and the palace had gone up in flames, burning all the documents that might have been used in extradition cases. During the years that followed, this event was erased from public memory. Yet it came to be ground zero of Salcedo's later trajectory, and the *point de départ* of her first major temporary installation in urban space.

It was only with *Noviembre 6 y 7*, the installation at Bogotá's Palace of Justice in 2002, that her work met the standard definition of installation art as the creation of a cohering structured environment, that is, installation as a single work. It was followed by other site-specific works, such as her 2003 Istanbul Biennale contribution of *1500 Chairs*, or *Shibboleth*, her installation in the Turbine Hall of London's Tate Modern (see Chapter 6). But it had been this massacre of 1985 that impelled Salcedo to focus her art on *la violencia*, the decades-long festering civil war in Colombia. Her early sculptures testify to that (see Chapters 1 and 2). It took 17 years until she translated this by then successful approach to sculpture into a work in urban space in the center of Bogotá, articulating a powerful memory that, in the absence of any public investigation of the 1985 event, could only be marked by its date, *Noviembre 6 y 7*, a date that failed to mark the year, thus signifying traumatic repetition.

Empty chairs, lowered slowly from the roof of the rebuilt Palace of Justice for the duration of the performance, are central to this work, reminding spectators of the powerful use of chairs in Salcedo's earlier sculptures. The difference is that this work, in and with urban space, is not about uncanny familial spaces of unsettlement and mourning, but about the erasure of a salient moment in the history of the city and the nation. It speaks to the absence of a collectively articulated memory of a national traumatic event.

The work's genealogy illuminates Salcedo's dogged work on documentation against all odds and thus speaks to the work

as social fact (Adorno). Since 1995 Salcedo had tried to get access to the Palace of Justice for her project. Her requests were ignored by the Ministry of Justice, but she persisted. With the help of an architect sympathetic to her endeavor, who gave her access to the Palace on nights and weekends, she and her team managed over several months to prepare the installation secretly on the roof of the building. And just when the whole project threatened to fail for lack of permission, the Supreme Court came through in the afternoon of 5 November 2002 and allowed her to go ahead. Her meticulous preparation had paid off. Long before the later trials and investigations of the event and before President Santos's official apology on the 30th anniversary of the massacre, Salcedo also had achieved illegal access to much of the documentation (photos, autopsy reports) of the killings and mysterious disappearances of cafeteria workers and of the timeline of those fatal 53 hours. This research then allowed her to structure the sequence of chairs lowered from the roof, which allegorically translated events that had transpired inside, and inscribe them on the outside facade of the reconstructed building itself, thus breaking the public silence about this major trauma that the city of Bogotá had suffered.

On 6 November 2002, her ephemeral installation began at 11:35 am, the exact time the M-19 guerrillas had entered the building killing a guard, and it ended, like the event itself, 53 hours later. A first empty chair was slowly lowered from the roof. As time went on into the afternoon and the evening, ever more chairs, pointing to the victims of the siege, came down the facade, sometimes singly, sometimes in clusters and at different speeds, all related to the reconstructed sequence of events inside the Palace of Justice. It was as if something formerly hidden from public view inside the building was slowly revealed to the public on the outside. Haunting as it was, this demonstration remained indirect, in line with Salcedo's sculptural practice. Hung from invisible wires, the chairs were moving sideways, upside down or backwards on the two facades of the building facing the Plaza de Bolivar, that very

central public plaza where Salcedo in later years organized several other installations as acts of public memory, mourning victims of Colombia's civil war. As night fell and public streetlights came on, the chairs cast shadows on the white-grey walls of the building, giving the whole installation a ghostly presence, now preserved only in the stunning photographs and video documentation. The inherent transitoriness of the installation speaks to the fleetingness of memory itself and to its insufficient preservation in visual media (fig.10).

Salcedo herself spoke of *Noviembre 6 y 7* as an 'act of memory'.[1] An act is something that has to be performed by an actor or agent. However, the artist herself, contrary to much other performance art but in line with her other work, remained absent in this performance. Transitory as other performance art pieces, this act of memory negotiated monumentality in counter-monumental form. It dissolved the static monument of the rebuilt Palace of Justice into a temporary sequence that gained its aesthetic power from its imaginatively abstract and minimalist reenactment of a horrific event. If the 1985 event had been traumatic, present only in traces in the public sphere, its sudden and unexpected reappearance in altered form as a public act of memory in 2002 had a powerful effect on passers-by who now witnessed it in a shock of recognition. Salcedo, present at the site for its duration, spoke to many people witnessing the reenactment. They told her time and again that they remembered exactly where they were and what they were doing at the time of the massacre. The project certainly succeeded in garnering public attention for what had transpired 17 years earlier. The media covered it only modestly as a memory event, but not as a work of art. Clearly it helped initiate legal prosecutions leading to indictments and to a public reckoning with events that had been previously erased from public memory.

One year after *Noviembre 6 y 7*, Salcedo created another major work of public art for the Istanbul Biennale of 2003, called *1550 Chairs*. She chose an empty space between two buildings in Istanbul, filling it with approximately 1550 wooden

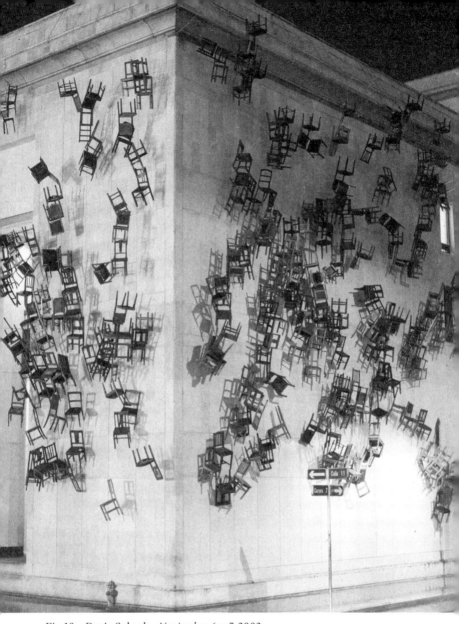

Fig.10 Doris Salcedo, *Noviembre 6 y 7*, 2002
280 wooden chairs and rope, dimensions variable,
ephemeral public project
Palace of Justice, Bogotá, 2002

MEMORY ART IN THE CONTEMPORARY WORLD

chairs stacked tightly between the two buildings framing the installation on either side. She had excavated the ground and installed several steel columns, which served as scaffolding for the chairs. The assemblage of empty chairs at the heart of an installation had moved from gallery space to public urban space in Bogotá and now to a transnational space in Istanbul. Given that her work was always connected to international practices, Salcedo was never simply a local informant about Colombia's civil war. But now her memory work took on a genuinely multidirectional dimension. Again, site-specificity in Istanbul was key. The empty lot she had chosen was in the formerly Greek and Jewish, now rather derelict Istanbul neighborhood. Again, the empty chairs conjure absence, absence in this case related to migration, displacement and violent expulsion that took place in the early years of the post-Ottoman secular Turkish Republic in the 1920s. The precision with which the chairs were arranged to suggest a flush facade when looked at from the side and a chaotic, disorganized jumble if viewed frontally, conveys both the expellees' experience of chaos and the bureaucratic streamlining of the expulsion. And again, the human body is present only in the trace. The installation lasted no more than three months once the Biennale closed.

Like *Noviembre 6 y 7, 1550 Chairs* was a temporary installation. Both installations run the risk of being forgotten again, at best leaving a memory trace among those who experienced them in situ. Turkey today is of course the site of another wave of migration from the Syrian civil war. Many of those refugees tried to cross the Mediterranean toward Greece, leading to untold tragedies of drowning, which in turn gave rise to another more recent work by Salcedo entitled *Palimpsesto*, shown to great acclaim at the Palacio de Cristal in Madrid in 2017 and a year later at London's White Cube.[2] While *Palimpsesto* is not a work in outside urban space, it took up a major public debate in Europe challenging European policy failures and the lack of empathy with the plight of migrants, refugees and asylum seekers.

Salcedo's trajectory has remained bifurcated since 2002. New work for galleries and museums has been accompanied by

several major projects of public mourning installed in Bogotá's center. Commemorating the FARC murders of 11 members of the state parliament of Valle in 2007, she placed a grid of 24,000 candles on the Plaza de Bolívar. As night fell, the candles were lit by the many anonymous people participating in the event. Those acts of public memory for specific victims of Columbian violence follow more traditional mourning rituals with their display of candles or, in other cases, roses or the writing of names, but they, too, have powerfully participated in the creation of a Colombian memory culture.

<p style="text-align:center">*</p>

Among all the artists from the Global South discussed in this book, William Kentridge (b.1955), South African of Eastern European and Lithuanian extraction, is perhaps the one most intimately and explicitly engaged with European traditions. He has staged and directed European plays and operas from Mozart, Monteverdi and Büchner to Alfred Jarry, Alban Berg and Shostakovich. Visual elements and strategies from early animation film (Georges Méliès) and expressionist drawing to Soviet avant-garde techniques are spread liberally throughout his work. And yet, his abiding appropriation and critical transformation of modernist European traditions from a South African vantage point is always embedded in his critique and self-critique of colonialism and empire. His work is a prime example of the *Entgrenzung* of drawing, his main medium, toward theater, opera, animation, dance and music, while also functioning as appropriation in reverse of key moments of European modernism.

There are major differences between Salcedo's and Kentridge's interventions in public art and the transformation of urban space. While both created temporary installations that had broad public impact, Salcedo had chosen a prominent and representative urban space – Bogotá's downtown Palace of Justice – while Kentridge worked with a rather disreputable heterotopic space: the neglected limestone embankments of the

River Tiber in Rome that have long been a site for queer sexual activities and homeless encampments. Salcedo's project focused on one major and, for her, formative event in the history of Colombian violence. Kentridge created an epic work of memory in fragments on the embankments of the Tiber, spanning several millennia of Rome's history. For both, it was their primary studio practice of sculpture and charcoal drawing respectively that served as ground for their projects in urban space. The intimate scale of their studio work was monumentally enlarged and transformed into an ultimately counter-monumental public performance. It is this proximity of their public interventions to their studio practice that enabled entirely new forms of public art in the mode of the temporary installation.

Kentridge's *Triumphs and Laments: Project for the City of Rome*, a large work in open urban space, strikes one as monumental indeed, at least at first sight (fig.11). Creating 51 images over ten meters high and covering a straight, 550-meter-long stretch of the steep embankments of the Tiber was certainly a monumental effort. It was not, however, a monumental history pageant of the rise and fall of a legendary European empire, as a viewer familiar with Kentridge's earlier critiques of colonial Empires, including the Italian one, might suspect. The focus was not Empire, but the eternal city itself, in the midst of which the project was located. It was the scale, not the content that was monumental. The procession of images chosen to represent the history of Rome did not lend themselves to a heroic narrative, and not just because of the inclusion of laments. After all, laments can themselves be monumental as well. This project was counter-monumental in another sense. Monuments are meant to last through time. *Triumphs and Laments*, on the other hand, was constructed to fade from view and to vanish slowly over time.

The history of Rome is peppered with triumphal processions. They were always temporary, following on the heels of successful military campaigns. They served to anchor the greatness of Rome in the minds of both conquerors and conquered by displaying the loots and spoils of conquest and war. Processions

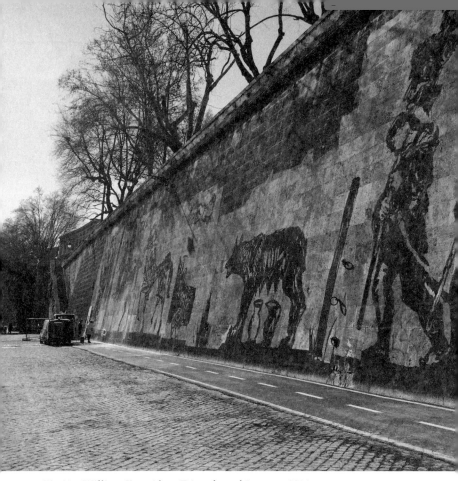

Fig.11 William Kentridge, *Triumphs and Laments*, 2016
Frieze, Piazza Tevere, Rome

also have a deep history in Kentridge's own work, from the *Shadow Procession* of 1999 to the *Refusal of Time* of 2012, and the later *More Sweetly Play the Dance* (2015) and *The Head and the Load* (2018) (see Chapter 4). The extended yet finite temporal dimension of this urban installation, different from that of the typical triumphal procession, becomes evident if we look at the genealogy of the project, its material realization and its projected after-life.

The site for *Triumphs and Laments* was first suggested to Kentridge 12 years earlier by Kristin Jones, founder in 2004 of the Tevereterno, a non-profit organization designed to produce cultural events centered on the Tiber. Kentridge eagerly took up the challenge to create a major urban project, which would be based on his privileged medium of charcoal drawing. After an initial plan to have large-scale images projected onto the Tiber's embankments was dropped as too expensive and impractical, first drawings for the project were made in 2011. The site of the embankments between Ponte Sisto and Ponte Mazzini posed a formidable challenge in scale, both in length and in the height of the embankments. Kentridge developed a process that Jones had experimented with earlier. He created a sequence of images that would represent Rome's triumphs and laments, using the vertical stone walls, as it were, as a blank canvas.

Each image started as a charcoal drawing that was then transferred to a somewhat larger size in ink, scanned into a computer and enlarged into a huge stencil to be hung from the embankments. The ink version was necessary because the production of stencils required clear lines, not the blurred outlines in various shades of black and grey typical of the charcoal drawing. The stencils in turn were another part of the process toward the end result. The final image emerged as the space around the stencils, and blank spaces within were pressure-hosed, thus exposing the bright limestone and leaving the image consisting now of the darkened soot, grime and organic growth on the embankment once the stencils had been removed. It was creation through erasure, a technique central already to Kentridge's charcoal drawing for his stop-motion-

animated films (see Chapter 4). But here the erasure resulted in a kind of drawing in reverse. The temporal complexity of this production process is matched by the simplicity of its effects. Clearly, like all memory, this installation would not be permanent. As pollution, lichen and organic growth would increase again over time, the image would fade into its darkening background and once more become part of the uniform, dark organic matter on the embankments. Within five years, it was estimated, the images would become invisible again. The play of visibility and invisibility in Kentridge's mnemonic device on the history of Rome points to the inevitable fact that memory itself always risks being short-lived, subject to oblivion, even as the memory of *Triumphs and Laments* might live on among those who experienced it in 2016. Soon, however, the work will be visible only in recordings and in digital format online.

The counter-heroic dimension of the project reveals itself not just in the coupling of triumphs with laments. As Kentridge once put it: 'Everyone's triumph is someone else's disaster.'[3] Despite three years of team research into the history of Rome, which amassed over 300 salient images from the archives of art, history and popular culture, his choices for the frieze were often idiosyncratic. As he said on another occasion: 'Any clarity we bring to understanding history is always a construction out of chaos.'[4] For such a construction the artist will claim more freedom of choice than the historian. Historical montage via the idea of constellations or superimpositions of different timeframes has been standard fare in modernist art practice. Montage sheds new light on history itself by opening up the temporal dimensions of the historical imagination and the processes of memory. Thus the frieze's images refuse chrono-logical ordering. They include silhouettes of emperors and popes, mythic figures like Romulus and Remus, and the she-wolf who suckled them, the goddess of victory in several stages of triumph and defeat, references to films and popular culture, a bust of Cicero, the rape of Lucretia, political figures like Mussolini and Aldo Moro, biblical icons like Jeremiah and

St Peter. The sequence of images does not just suggest anachronism. Where there is no chronism, i.e. a historically orderly progression, the notion of anachronism doesn't make much sense. The organizing temporal principle is rather the simultaneity of the non-simultaneous, most visible in the superimposition of the image of the Renault in which Aldo Moro's body was found after he was murdered by the Red Brigades in 1978, Bernini's mid-17th-century sculpture of Santa Teresa in Ecstasy and a detail of a battle scene between Romans and barbarians from a mid-third-century marble sarcophagus. At the other end of such a condensation of timelines, a knot of time in the memory image, is the image of a big black square, reminiscent of Malevich, which carries the inscription in parenthesis: 'That which I don't remember.' Significantly it is juxtaposed with an image of two deportees, hands raised in surrender, based on a 1944 photograph of SS victims in Italy. If the simultaneity of the non-simultaneous is one underlying principle, repetition and reiteration in changed form is another: thus the Roman she-wolf appears both in healthy shape and as a skeleton with hanging head, burdened by history; Popes, mourned or deposed; Cicero's bust in whole and in fragmented form; horses and riders in various positions of triumph or collapse; the Goddess of Victory, recording a victorious cam-paign on a shield in triple form, upright, falling and ultimately as if beaten down. And finally the Triumph of Death, a grim reaper skeleton on horseback, sword drawn, riding into battle.

Kentridge was very aware of the site's specificity, located as it was between the Vatican and the former Jewish ghetto. One image shows how the spoils from the Temple of Jerusalem, depicted on the Arch of Titus, are carried along in the proces-sion; another shows partisans captured by the Germans. A boat of migrants approaching Lampedusa, taken from a 2013 photograph, is anachronistically equipped with triremes typical of an ancient fleet. References to death are frequent, with dead bodies lying on the ground: that of Remus murdered by his brother; that of Pier Paolo Pasolini, the assassinated gay filmmaker; and that of Anna Magnani, playing a victim of Nazi

soldiers in Rossellini's film *Rome, Open City* (1945). Deportees, contemporary migrants and refugees from the 1937 flood of the Tiber are in close proximity to each other, suggesting possible linkages to be made by the spectator. The image of deportees and the one of partisans, both with hands raised, frame the black square, the image of oblivion. A lighter touch, rare in the sequence, appears in the image that shows *La Dolce Vita's* Anita Ekberg and Marcello Mastroianni not in the Trevi Fountain as in the 1960 film, but standing in an old-time bathtub.

Ultimately the question arises whether some logic or some narrative thread holds the frieze together. Not surprisingly, there is no clear answer to this question. Kentridge is loath to give history lessons. He makes spectators think about potential links among the images. But it seems significant that in the very first image the Winged Goddess of Victory is represented facing forward, in the direction of the procession, toward the future, as it were. Most of the figures at the front end of the procession are indeed leaning forward, representing the direction of history's march. When the Winged Victory appears again in three progressively collapsing shapes later on, she is turned the other way, looking backwards toward the past, like Walter Benjamin's angel of history. As our eyes follow the frieze, reading from left to the right, ever more figures are moving backward. The juxtaposition of the boat with refugees from the 1937 Tiber flood, which points forward, and the boat filled to the brink with contemporary migrants from Africa, which points backward, marks the threshold. Subsequently, a now skeletal she-wolf with head hanging moves in the same direction, followed by a progression of migrants, the crucifixion of St Peter and women weeping for a Lampedusa shipwreck. This mournful sequence culminates with the prophet Jeremiah, taken from Michelangelo's fresco on the ceiling of the Sistine Chapel, and an image of Giordano Bruno, philosopher, scientist and cosmologist burnt at the stake in 1600 as a victim of the Inquisition. After a reminder of another Tiber flood in 1557, several more figures on horseback, a collapsing horse and a skeletal horse, all of them moving backwards toward the past,

seem to indicate the very futility of progress. This is history in reverse, triumph denied. In the end, the lament clearly prevails. It is accentuated by the penultimate image before a skeletal collapsing horse. An Italian infantry marksman with rifle in attack position, moves vigorously forward (i.e. backwards) toward the skeletal horse trying to move away from him at the end of the procession which casts a worried look backward (i.e. forwards) toward that rifleman. The continuity of war and thus the continuity of laments seems guaranteed with these concluding images.

The dual movement in opposite directions, which characterizes the frieze, was reiterated in the performance that opened the frieze to the public on 21 April 2016, 2769 years to the day since the founding of Rome. Two brass bands, each followed by a dance group – one symbolizing triumph, the other lament – moved slowly toward each other from the two ends of the frieze. The static frieze was thus coupled with a procession in motion. The dancers carried cut-out puppets above their heads, taken from the prepared image archive. Floodlights installed at the edge of the embankment created a moving procession of shadows overlaying the fixed images on the walls. When the two bands met in the middle, they simply walked through each other, creating an indecipherable hodgepodge of moving shadows behind them. The music composed by Philip Miller, long-time collaborator of Kentridge, included citations of Italian popular music and complex madrigal material, taken from Jewish composer Salomone Rossi, a contemporary of Monteverdi. It also included Zulu war-cries and Mandinka slave songs. In close analogy to the fixed images of the frieze, this dual procession in opposite directions and its mostly mournful music resembled more of a *danse macabre*, emphasizing the ultimate triumph of lament, if not defeat. Any forward march with the triumphal sound of trumpets was counteracted by the overall effect of this new kind of fragmentary *Gesamtkunstwerk*, the lamentful denial of historical progress.

The procession as shadow play in motion has been a constant in Kentridge's work, whether in relation to South African history,

European colonialism or the role of African soldiers in World War I. It is the black on white, the white in the black and multiple shades of grey in charcoal drawing on paper that ground his artistic practice, only occasionally supplemented by the colors blue and red. The play of shadows is inherently related to the very structure of memory. Even if *Triumphs and Laments* lacks the incisive critique of European colonialism, characteristic of works such as *The Refusal of Time* (2012) and *The Head and the Load* (2018), the frieze does include an image of Ethiopia's Haile Selassie, gesturing toward Italian fascism's North African colonial intervention, and the after-effect of colonialism is present in the boat with African migrants. The absence of a fully elaborated postcolonial perspective is not a sign of depoliticization. *Triumphs and Laments* prophesises imperial collapse and embraces a world-wide counter-monumental iconoclasm directed against the idea of great men making history, subverting today's re-emerging nationalist longing for strong men and heroes. At a time when the dismantling of monuments has become a public obsession, one may well ask for how long the counter-monuments and memorials erected in recent years will last. But that question is not pertinent for Salcedo and Kentridge's counter-monuments, whose vanishing was always already part of their construction.

The Shadow Play as Medium: Nalini Malani and William Kentridge

Central to an aesthetics of memory in contemporary art is the shadow play. Independently from each other, Nalini Malani and William Kentridge have developed innovative forms of this ancient practice of performance as a medium of traumatic memory and political reflection. A close look reveals stunning affinities underlying these works, which, on the surface, look so very different in their combination of media, materials and technical supports.[1]

The purpose of these shadow plays is not to represent traumatic pasts, but to create a flash of recognition in the Now, as Walter Benjamin might phrase it. In the passage from aesthetic fascination to reflection, the viewer is challenged to think about memory politics, dispossession, colonial and postcolonial violence in critically new ways. Memory of India's Partition of 1947 and of South Africa's decades of apartheid and their respective after-effects in the present determine these works in such a way that the very form of the shadow play stages not just aspects of this history, but the very structures of memory, erasure and forgetting. Spectacular theatricality is playfully and sensually bound to a rigorous formal exploration of what critical affective seeing might mean politically in contemporary artistic practice.

Kentridge's and Malani's technical treatment of the shadow play, their relationship to inter-war European avant-gardism, combined with the simultaneous use of local Indian or African

traditions, as well as the range of their material praxis makes them paradigmatic figures for any discussion of a globally interconnected memory art. Transnational appropriation and the role of media in contemporary art are central concerns they address. The shadow play as their chosen medium, grounded as it is in obsolete technical supports, deliberately sidesteps technologically advanced forms of digital art practice. At stake for current aesthetic debates are the specific forms of a spatial and temporal transformation of Western modernism, and the *Entgrenzung* (expansion) of its privileged notion of the medium in other geographies.

Both Malani (b.1946) and Kentridge (b.1955) belong to a generation of artists whose experience is shaped by colonialism and decolonization. Their works circle around the long-term traces of historical trauma, always in aesthetically complex forms rather than in documentary or agit-prop style. Both artists studied in Paris, but neither was taken with the then dominant Western trends of the 1960s and 1970s (Pop, minimalism, conceptual). As opposed to many other global artists, who have settled in a Western metropolis, they maintain their studios in their respective home cities, Mumbai and Johannesburg. Malani comes from a secular Sikh family from Karachi, forced to flee to India in the chaos of the Partition. Kentridge comes from a family of Jewish refugees from Lithuania that settled in South Africa several generations ago. Migration and exile are in both their backgrounds. Both have come to be known in biennales since the 1980s, especially those of Havana (1986 and 1989), Johannesburg (1995 and 1997), Brisbane APT (1996) and Istanbul (2003). Both have also worked in the theater, mobilizing Brechtian estrangement from a postcolonial perspective and combining it with theatrical spectacularity, narration and figuration to captivate their viewers. Both deploy literary models of modernism and the historical avant-garde. Alfred Jarry is for Kentridge what Heiner Müller is for Malani: models to be re-coded and re-functioned in South African or Indian contexts. European avant-gardist art and literature are present in their work as

montage, bricolage and appropriation in reverse, but never as canonical ideal or as nostalgic set-piece. Both privilege a leftist avant-gardism: Dada, Max Beckmann, Otto Dix, Brecht, Dziga Vertov and the Soviet avant-garde in the case of Kentridge; Brecht, Antonin Artaud, Chris Marker, Heiner Müller, Christa Wolf in Malani's. Both splash linguistic signifiers across their work and the interaction between the linguistic and the visual is constitutive for their aesthetic practices.

Both artists interweave avant-gardist montage with their respective local traditions of popular culture: reverse painting and 19th-century Kalighat figuration for Malani; the prevalence of charcoal drawing, etching and expressive renderings of everyday scenes for Kentridge.[2] Both combine these very traditional modes of representation with obsolete, but politically loaded support technologies: stop-motion animation film in Kentridge, and in Malani the magic lantern with its slowly revolving Mylar cylinders. All their projects are unabashedly figurative and narrative, but always with an umbilical cord to classic modernist experiments with what Adorno once called the fraying of the arts (see Introduction). Central to both artists is the hidden after-life of past violence that keeps re-erupting in the present.

∗

Nalini Malani was trained in painting at a time when figuration still held sway in India. After graduating from the Sir J.J. School of Art in Mumbai, she turned to lens-based media and made a series of cameraless photographs and experimental films such as *Dream Houses*, *Still Life* and *Onanism* (all 1969), *Taboo* (1973) and the double film projection installation *Utopia* (1969–76).[3] Her critical awakening to political issues was triggered by a two-year period of study in Paris (1970–2) which consolidated her incipient fascination with the moving image. Due to financial constraints, she did not become a filmmaker. Embracing a cinematic imagination, she turned back in the early 1970s to drawing and painting, which remained her artistic

medium for two decades.[4] At the time of the rise of Hindu nationalism in the early 1990s, which led Vivan Sundaram to create his installation *Memorial* (see Chapter 2), her work exploded the frame of these traditional media with a move toward installation and performance, including her first shadow play, *Alleyway Lohar Chawl* (1991), and her collaborative theater plays *Medeamaterial* (1993) and *The Job* (1997).

Her work then continued on two closely related trajectories. On the one hand, she created several series of reverse-painted large wall panels and *tondi* (circular paintings) on Mylar, mostly in acrylic, watercolor, ink and enamel – exuberantly colorful works that reveled in fragments of popular Indian and European myths, as well as contemporary references. In these works, memory images are constructed around female figures such as Medea and Cassandra from Greek mythology, Sita and Akka from Indian mythology, and more recent literary figures such as looking-glass Alice and Brecht's Mother Courage. Medea and Sita are pariah figures abused and rejected by society. Cassandra is endowed with the gift of seeing a calamitous future, but no one listens and she is not heard. Mother Courage, morphing into Mother India, loses her children to the horrors of war as she marches on through a landscape of devastation. In the midst of this procession of figures from Indian and European myths, there is little Alice with her insatiable curiosity, confronting a world that has lost its scale and its bearings.

On the other hand, Malani developed her signature medium of memory, the video shadow play with its revolving Mylar cylinders and their kaleidoscopic visual narratives, both mythic and historical, which cast moving shadows on the wall. These labyrinthine images transcend geographic and historical boundaries, but they are also firmly grounded in radical feminist politics. The shadow plays condense and superimpose three different time scales: the timeless mythic scale, which mobilizes ancient narratives of women pointing to the eternal recurrence of women's oppression; the 20th-century political scale framing the end of colonial rule, the Partition, the

Nehruvian secular state, its broken promises, and the increasing shift toward religious fundamentalism and Indian fascism; and, finally, overlapping with the latter, the accelerated capitalist present of a colonial postcoloniality with its neoliberal ideology invading India with a vengeance after 1989. These three dimensions are not anachronistically juxtaposed, but they interpenetrate each other, as they would in any living memory, which always features the simultaneity of the non-simultaneous.

Temporality is thus inscribed in two different ways into Malani's images. One is cyclical time as repetition and recurrence, formally represented in Malani's turning Mylar cylinders and their appearing and re-appearing images; the other is linear historical time, represented in series of mural-like panels such as *Despoiled Shore* (1993), *Splitting the Other* (2007) or *All We Imagine as Light* (2017). These panels are to be read sequentially from left to right with images often cut off at the right frame and then continuing by way of *enjambement* into the next panel. Still, there will be no coherently sequential story, just a kaleidoscopic flotsam of images that is beyond the order of perspective or scale. This makes it possible to read them in reverse, especially when the panels are exhibited in he round with the last panel touching the first. Memory and forgetting are embodied in both modes: memory is present in dream-like fragments of mythical or historical narratives; forgetting is present in erasure, an early element of Malani's practice from early on and made visible in the stop-motion animation technique used primarily in the video shadow plays.

Malani's Mylar cylinder technique was strongly influenced by the popular, late-19th-century Kalighat painters who created quickly executed paintings and drawings that could be reproduced easily by lithography. Originally focused on Indian gods and religious topics, this folk culture of Kalighat painting soon turned to populist secular imagery and depictions of everyday life. Malani's very first work with transparent Mylar, executed in the old reverse-glass painting technique that came to India from China in the 18th century, was *Alleyway in Lohar Chawl* (1991), a work that depicted

subaltern life in the poor Mumbai neighborhood where she had her studio at the time.

The effect of patriarchy on women's lives was the theme of her first performance piece in 1993, combining a series of large painted panels, slide projections, neon sculpture, Mylar paintings and video with a theatrical performance based on Heiner Müller's text compilation *Medeamaterial* (1982). Medea, as colonial subject and woman betrayed by her colonizer husband, Jason, did the unimaginable: she killed her children in an act of madness, rebellion and revenge. Medea, as subject of several rather grim paintings, then morphed into the arguably most dystopian series of all of Malani's work, called *Mutants* (1994–6). The series superimposes the fate of Medea (the *Mutant A* series, in color) with the fate of mutants resulting from the American nuclear tests on the Bikini atoll in the 1950s (*Mutant B* series, the only series in all of Malani's work in black and white). The nuclear threat loomed large after Chernobyl in 1986 and during the Indian/Pakistani nuclear arms race, which peaked in the 1990s. Mythic past and historical present merged in both series, one dealing with the female body degraded by colonialism, the other with the degendered body, genetically disfigured by technological progress. Mediated through the plays of Heiner Müller, the dialectic of myth and rational enlightenment resonates powerfully as Malani uses mythic narrative to shed light on contemporary patriarchy and to warn, Cassandra-like, about modern technology radiating catastrophe.

These themes resonate through all of Malani's later work. In Müller's *Medeamaterial*, a de-gendered mutant-like Medea says: 'I want to break mankind apart in two/And live within the empty middle/No woman and no man', lines which became a visual leitmotif for Malani.[5] They point to the brutal *informe* of mutilated, sexualized bodies that dissolve, as in the panel-painting series *Splitting the Other*, into formless blotches, decomposing pieces of jellied flesh and brain, loose vertebra, sheathed genitals, accompanied by floating excrement, body organs and embryos on umbilical cords precariously connected

to the maternal figure of Mother Courage marching through a landscape of devastation. This unique visual vocabulary, which emerged from Malani's earlier training as a medical textbook illustrator and reflects psychoanalyst Melanie Klein's notion of the fragmented body, emphasizes the debasement of the human form, but not a currently fashionable anti- or post-humanism. It is rather a way of viscerally recognizing the bodily effects of the othering that leads to scapegoating, violence and real mutilations in a specific historical and global context. Memories of mythic narratives and of traumatic histories merge in this kind of thinking through images. It is characterized by the dialectic of despair and rebellion, horror and beauty, without ever risking aestheticization or voyeurism. Malani secures an ethics of the gaze to the extent that the work refuses facile readings and engages the spectator in difficult cross-cultural translation. In the end, however, there is the faint hope that Cassandra will be heard.

As if to escape from the relentless horror conveyed by the Medea and Mutant projects come the compellingly beautiful shadow plays, aesthetically and conceptually the glowing core of Malani's memory work. In *Remembering Mad Meg* (2007–17), eight large cylinders are lined up between gallery walls. The dream-like images painted in bright colors on the transparent plastic feature aspects of the ancient Indian epics, which still today have a vibrant presence in Indian popular culture. The spectators find themselves in a darkened gallery caught between the turning cylinders with their luminous images moving in the round on one side, and the flat shadows on the other. The two-dimensionality of the floating shadow figures on the wall confronts the three-dimensionality of the turning cylinders and their painted human figures, animals, demons, plants and mythic personages. The spectators' silhouetted shadows become part of a spectral re-enchantment as they move through the darkened space between projection on the wall and slowly whirring cylinders. Looped soundtracks mixing voice, instruments and natural sound from urban environments shape these spectral impressions.

Shadow plays such as *Remembering Mad Meg*, which draws on the figure of a mad rebellious woman in Pieter Bruegel's *Dulle Griet* painting of 1563, add video projections. Here images come in four registers: the painted images on the Mylar cylinders, their shadows on the wall, the video images projected through the cylinders, and the ever-changing combinations of the painting, shadow and video images on the wall. In *Remembering Mad Meg*, four separate video projections, each overlaid by the shadows emanating from the turning Mylar cylinders and each with its own theme or storyline, consist of drawings filmed sequentially shot by shot. Erasure, addition and transformation work their magic in these stop-motion animations.

Perhaps Malani's most compelling video shadow play is *In Search of Vanished Blood* (2012) (fig.12). The title derives from a poem by Pakistani poet Faiz Ahmad Faiz, a poem that conjures up the genocidal and femicidal violence of the 1971 partition of Bangladesh from Pakistan. This work consists of five hanging Mylar cylinders turning slowly like Buddhist prayer wheels. The projected images are again superimposed palimpsest-like by the shadows cast from the figures painted onto the turning cylinders. The projections show Cassandra's body used as a canvas/screen on which her prediction of the near future is inscribed, like experience etched on her skin.

The superimposition of slow-moving cyclical shadow effects and the fast-moving projections requires patience and immersion on the part of the spectator. Mythic material casts shadows on image montages that concern problems in the present: mutilations by landmines, executions, oppression of women. There are images referring to the tribal protests against dispossession in the North of India, newspaper photographs combined with citations from Goya's *Los Desastres de la Guerra* (1810–20), Cassandra's face covered with a cloth as in the practice of waterboarding used on detainees at Guantanamo Bay. An animated hand tries frantically to speak the word 'Democracy' in American sign language. Speeds and scales are out of sync with each other, creating a fast-changing

Fig.12 Nalini Malani, *In Search of Vanished Blood*, 2012
Installation view at ICA, Boston, 2015
Six-channel video/shadow play with five reversed painted
Mylar cylinders, sound, 11 mins, dimensions variable
Burger Collection, Hong Kong

kaleidoscopic movement of repetitive image loops. In an interview, Malani commented on her project:

> Darkness is more potent than light. It just needs a shadow and you can obliterate light ... If you take that further with ideas: how quickly something that has to do with enlightenment or revelation can be completely destroyed, and very quickly by the 'shadow of doubt' or a moment of skepticism. I think that that's one aspect of the shadow. Because a shadow is very strong, it has no materiality and yet it's so strong.[6]

Even if shadows threaten the power of enlightenment, they also make us aware of what stands in its way. In a key projection, we see the head of a young woman, wrapped completely in a white bandage onto which are projected the opening lines of the poem by Faiz Ahmad Faiz referred to in the work's title (fig.12). In repetitive loops the shadow of a vile, roughly drawn mythical creature passes over this bandaged head. The creature holds two captured human bodies in its cancer-like fangs and gulps down a naked child into its beak-like maw. The motif of the destructive monster must be linked to other images of the work: a Cassandra figure foretelling doom and Kali, the Hindu goddess of doomsday and death, painted on the cylinder in Kalighat style. The unifying theme is violence.

In Search of Vanished Blood superimposes the spaces of Indian and Greek mythology, the time of partition and its repetitive violent after-effects, and the time of global capital and its destructive effects in the agrarian Indian hinterland as well as in India's megacities. This montage is not formally united by some defined spatial perspective. Unmoored images float through space in repetitive loops. The poem by Faiz Ahmad Faiz, projected onto the white bandaged head as if onto an empty page, makes it clear that it is not only partition that is at stake:

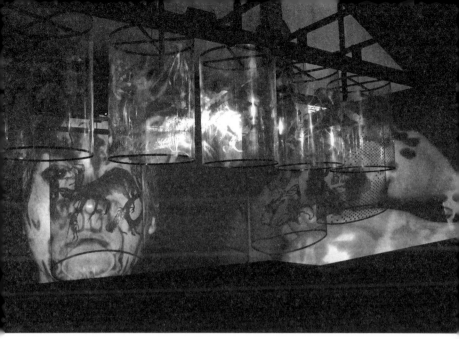

Fig.13 Nalini Malani, *In Search of Vanished Blood* (detail), 2012
Installation view at Castello di Rivoli Museo d'Arte Contemporanea,
Turin, 2018
Six-channel video/shadow play with five reversed painted
Mylar cylinders, sound, 11 mins, overall dimensions variable
Burger Collection, Hong Kong

There is no sign of blood, not anywhere.
I've searched everywhere.
The executioner's hands are clean, his nails transparent.
The sleeves of each assassin are spotless.
No sign of blood: no trace of red,
not on the edge of the knife, none on the point of the sword.
The ground is without stains, the ceiling white.

Faiz wrote the poem as a reflection of the violence in East
Pakistan that led to the creation of Bangladesh in 1971.
The monster, however, says Malani, can be read as an allegory
of the land-grabbing multinational corporations who drive
the indigenous rural poor in West Bengal and other areas
from their land in order to mine valuable minerals like bauxite.
Resistance against these expropriations from above is organized
and led by the tribals, the so-called Naxals, who have resorted
to arms. Here again Malani draws on a mythical literary figure
from the *Mahabharata*, rewritten and modernized in Mahasweta
Devi's *Breast Stories* (1997), to represent resistance: Draupadi,
Dopdi in Naxal dialect, the story of a woman who refuses
to abandon her land and is gang-raped by the police. In a
stop-motion animation drawing, projected through the cylinder
featuring the corporate monster, we see a young woman in a
sari holding a baby metamorphose into a uniformed resistance
fighter holding a rifle. Both drawings reproduce newspaper
photographs from the Naxal milieu. The soundtrack then
transforms the Draupadi figure into a Cassandra in revolt.
Only as one considers the soundtrack does it become evident
that Malani's cyclical narrative aims at resistance and revolt:

This is Cassandra speaking./In the heart of darkness.
/Under the sun of torture./To the capitals of the world.
/In the name of the victims./I eject all the sperm I have
received./I turn the milk of my breasts into poison.
/I take back the world I gave birth to./I bury it in my
womb./Down with the happiness of submission.
/Long live hate rebellion and death.

This of course is not the Cassandra of Christa Wolf's 1983 novel speaking, a strong literary influence on Malani, but it is the voice of Ophelia/Electra at the conclusion of Heiner Müller's *Hamletmachine* (1977): radical revolt against a male-dominated world. Cassandra-Draupadi stands for the armed resistance of the tribals defending their land. The Heiner Müller quote indicates that colonization itself is at stake with this feminist rebellion.

Malani's multi-layered montaged narrative can bewilder the viewer. Her moving-image worlds require attentive reading, reflection and translation. It is not easy to enter into this 11-minute-long palimpsest of shadow figures and projections that mix European and Indian traditions with in-your-face political motives in their aesthetic construction. The knowledge of Wolf's *Cassandra* and Müller's *Hamletmachine* is not enough to understand the specific Indian dimensions, but it provides an entry for the Western spectator who is challenged to develop a transcontinental hermeneutic understanding. Translation is also demanded of the South Asian spectator. Malani stages the past not as a husk filled with past moments of time, but as a moving image filled with present-day emotions projected onto that past. Then it becomes, in Malani's words, a living memory, which she sees as her endeavor as an artist to set in motion a process for the viewer to understand and experience the present anew.

Malani's video shadow plays strike me as a kind of writing in images and sounds that interrogates the deep structures of history by brushing lived experience against the grain. All her work has a hieroglyphic dimension that reveals itself only to slow and patient readers willing to defer an immediate gratification of meaning and to submerge themselves in dream-like montages of moving images or in the sequences of serial paintings and watercolors, the video installations and the post-dramatic theatrical performances. Clearly, her reverse (hi)story-telling through mythic images challenges Western notions of 'History' as progressive temporality, an intellectual challenge that, in the wake of postcolonial theory, has become widespread. But in her critique of Hindu fundamentalism, the

Indian state's nuclear hubris and the violence done to women, Malani also challenges the silences in the self-understanding of the Indian secular state. This work thus operates at the threshold of the local and the global and at the threshold of visibility itself. It tries, in Malani's words, 'to make visible that which is invisible', to make audible that which is not being heard.[7] *Listening to the Shades*, the title of a 2008 Malani exhibition in New York, is what Cassandra, one of Malani's touchstones, does when she foretells doom in the hope to defer and avert it.

<p style="text-align:center">∗</p>

In his early years, William Kentridge wavered between the theater, film and the visual arts. He exhibited drawings, designed sets for film production and directed plays. Engaged in political protest after the Soweto riots of 1976, he soon abandoned the literalist didactic forms of agitprop theater dominant at the time and developed subtler political resonances, experimenting with aesthetic forms and media. Rather than narrowing, however, he expanded the range of his artistic endeavors to include photography, animation, installations and opera stagings. Image, language and sound interact in most of his subsequent works without ever aspiring to a *Gesamtkunstwerk*. If there is one privileged medium in his versatile oeuvre, it is charcoal drawing. No coincidence then that he found his voice in his *9 Drawings for Projection*, most of them produced between 1989 and 1994, key years of political turmoil in South Africa that announced the end of the apartheid regime. In a spectacular intersection of memory politics and aesthetic practice, this body of work represents a breakthrough toward the play with shadows that found its paradigmatic example in *Shadow Procession* (1999) and its conceptual description in his lecture *In Praise of Shadows* (2001).[8]

While *Shadow Procession* deals suggestively with the muta-tions of memory after South Africa's transition to democracy, a strong commemorative dimension is already starkly present

in the very medium of the *9 Drawings for Projection*: his use of stop-motion animation film. When he called it Stone Age animation, it was a tongue in cheek homage to Georges Méliès's early cinematic experiments. A charcoal drawing is photographed, minimally changed, photographed again, and so on and on until a sequence in motion emerges. The images are literally generated in slow motion, as the artist walks back and forth between the drawing and the film camera. Each sequence, rather than each frame of the film, is based on a single drawing. There were no scripts, no storyboards. Different base drawings mark the jump cut from one scene to another. Drawing by drawing, scene by scene, a film of moving images emerges from this stop-motion animation technique. Kentridge himself has often described drawing itself as a slow-motion version of thought.[9]

Remembering and forgetting are visually inscribed into this practice of charcoal drawing, which anchors all his animations. While the shadows of human figures, animals and objects that we see in *Shadow Procession* are based on black paper cut-outs with movable limbs, mounted one behind the other and moving jerkily from shot to shot, the shadow structure of the *9 Drawings for Projection* is of a very different nature. Here the shadow is the preserved trace of the erasure, a stain or a barely visible outline of bodies, buildings, objects, which points to the preceding version of each drawing. The medium becomes palimpsest. Continuous metamorphosis is the guiding principle in the progression. Erasure becomes a metaphor for the instability of historical memory. Except that what is erased, effaced or wiped out in these drawings is the violence of South African apartheid and its traumatic after-effects. What remains in the movement of time and images is the trace. The *Drawings* thus offer not only self-reflection in the fascinating bricolage of charcoal drawing and animation. They reflect the structure of political memory itself, which, after the end of the apartheid regime, was subject to erasure, evasion and forgetting. The metamorphosis of that which is remembered corresponds to the metamorphoses in the creation of the charcoal drawings.

The commonplace binary of memory versus forgetting as an either/or is belied by the preservation of traces of the past as shadows, stains, mnemonic outline in the drawings, all the way to the traces of charcoal dust visible on paper and in the film. The past remains materially present, even if only hinted at in shadow-like residues. To remember means to read traces, it demands imagination, attentiveness of the gaze, construction of the past and, above all, relentless honesty in the attempt to make visible that which society tries to condemn to invisibility.

The *9 Drawings for Projection* are narratively connected with each other. They revolve around two characters, the ruthless Johannesburg entrepreneur and developer Soho Eckstein and the melancholy artist-intellectual Felix Teitlebaum, both of them heavy set, balding, middle-aged Jewish men like Kentridge himself. He called them 'displaced self-portraits'.[10] Their intimate resemblance is further exacerbated by a love relationship Mrs Eckstein entertains with Felix before she returns to her husband. The narrative device of the Soho-Felix relationship thus critically acknowledges the artist's own role not as perpetrator or victim, but as beneficiary and bystander of the apartheid regime. In that sense Kentridge was right when he spoke not of a self divided, but of an attempt to mediate between different parts of the self.[11] This splitting of the self remained a leitmotif in later works whenever Kentridge confronted his activities as an artist visually in his work. Multiple selves correspond to Kentridge's conviction that identity is fluid rather than stable and fixed, that metamorphosis is constitutive of life itself. Eckstein always appears in his standard striped business suit, which serves like an armor as he confronts poverty and race in Johannesburg; Teitlebaum is shown always naked, marking his vulnerability and self-consciousness. While the representation of these alter egos shares aspects with the graphic novel, even the popular cartoon, the emplotment of their story is anything but straight-forward. Ultimately, however, the split between Soho and Felix is grounded in an exploration of the conflictual white

South African psyche in the midst of historical crisis, which is the central theme of all the *9 Drawings for Projection.*

From early on a critic of the apartheid regime, Kentridge was always self-reflexively aware of his own implications as a beneficiary of apartheid. Thus the political critique of memory erasure in post-apartheid South Africa is sharp and concise. Three of these films, *Mine* (1991), *Felix in Exile* (1994) and *History of the Main Complaint* (1996), exemplify this critique. Each one projects a different dimension of South African memory politics in the 1990s. In all three, landscape becomes a memory space of visible and invisible social conflicts, a place of exploitation, manslaughter and murder. In its industrial deprivation and stony flatness, the East Rand near Johannesburg, a landscape of de-industrialization and derelict gold mines, is a negation of landscape in any emphatic sense, most certainly a negation of traditional landscape painting, which in the South African context was always invested in lush fantasies about Africa. Kentridge draws telegraph poles, electrical pylons, sinkholes, drainage dams and gigantic mine dumps. The land's scarred surface reminds us of past labor in the mines below, the exploitation and oppression of the black miners on whose backs the wealth of Johannesburg was built.[12]

The central figure in *Mine* is Soho Eckstein, the mine's owner. The film begins as an ever-growing crowd of miners emerges from the lift cage of the mine transporting them to the surface and bringing them into visibility, just as in the years after 1989 large demonstrations surged into the streets of Johannesburg. Eckstein, propped up in the cushions of his bed, experiences this social surge as a welling up of the bed's blanket and as a threat to his control. After the top of the mineshaft metamorphoses into a cash register, the viewer gets to see the brutal reality of mine labor through the surreal metamorphosis of Soho's cafetière into a power drill. The cafetière as drill translates the relation of capital to labor, thus establishing a visual link of the above with the below. From Soho's table it drills relentlessly downward to the subterranean shafts and tunnels of the mine. It moves through the workers'

shower-room and sleeping stalls, which resonate with photographs from the barracks in Dachau and Buchenwald. In another image, the layout of the mine's tunnels and caves seen schematically from above turns into the layout of a slave ship's hold during the Middle Passage. In the end, however, it is only profit that interests Soho Eckstein, and the film concludes with the appearance of a toy-size rhinoceros on Soho's bed, a pet, as it were, which gives African identity to the white entrepreneur. Indeed, it is the colonial history of the Johannesburg landscape that Kentridge compresses sharply into his image animation.

By comparison with *Mine*, *Felix in Exile*, made in 1994, the year of South Africa's first democratic election, seems more melancholy, if not conciliatory, and anxious about the future. Felix appears as counter-image to Soho, lost in a sparsely furnished hotel room and examining a trove of drawings from a suitcase, many of which then fly up and decorate the walls, as if it were an art gallery. The room itself is modeled after a photo of the exhibition space of *The Last Futurist Exhibition of Paintings 0–10* (1916), signaling the relation of Kentridge-Felix to Malevich's *Black Square* and the Soviet avant-garde. But in this film, too, the landscape offers traces of a violent hidden history. Given Kentridge's Jewish backround, Felix's exile, after all, may well be metaphoric rather than real. The main plot revolves around Felix's relationship to Nandi, a black Cassandra figure drawing forgotten legacies of a violent past. As the author of the drawings that Felix looks at, she enters his life in a phantasmatic way. As he looks into a mirror to shave, his image fades and is replaced with Nandi's face. They look eye to eye through a double-ended telescope, combining closeness and distance, thus guaranteeing that the color line between him and his new mirror image would not simply disappear into some false identification (fig.14). They are linked, but as separate as black and white. Equipped with a theodolite, Nandi examines the landscape's topography and discovers traces of its violent past as she looks through the telescope. The land she surveys and draws is littered with slain bodies bleeding into

Fig.14 William Kentridge, *Felix in Exile*, 1994
35 mm animated film, transferred to video and DVD, 8 mins 43 secs
Tate

the ground. They are then metaphorically and literally 'covered' by newspapers, melt into the landscape and become invisible, as erasure in the double political and aesthetic sense takes hold. Here Kentridge drew on forensic police photos from the 1960 Sharpeville Massacre, one of the first major demonstrations against the apartheid regime. As Felix stands eye to eye with this female land surveyor sharing her vision, she appears both as a motherly figure and as a figure of erotic attraction. Water flows from the mirror into the sink, eventually inundating the whole room, destroying the drawings and collapsing its walls. Nandi, too, becomes a victim of violence, with her half-dressed body metamorphosing into a heap of dirt and then into a water-filled sinkhole in the landscape. In the end, we see a naked Felix from behind standing in that sinkhole, helpless and at a loss, before this film breaks off without narrative conclusion.

Kentridge had this to say about the central role of counter-landscape in his films:

> I'm really interested in the terrain's hiding of its own history, and the correspondence this has ... with the way memory works. The difficulty we have in holding on to passions, impressions, ways of seeing things, the way that things that seem so indelibly imprinted on our memories still fade and become elusive, is mirrored in the way in which the terrain itself cannot hold on to the events played out upon it.[13]

On the one hand then there is the difficulty of holding on, keeping memories alive; on the other hand, Kentridge spoke elsewhere of the possessive rock of apartheid, its heaviness and immobility standing in for the weight of the past, which can be neither evaded, nor represented directly. And yet the *9 Drawings for Projection* as a medium of memory do offer a way of holding on to seeing and to knowing.

The most explicit reference to the apartheid regime comes in *History of the Main Complaint,* drawn and filmed in 1996,

year of the first hearings of the Truth and Reconciliation Commission, whose Christian ethics of forgiveness as liberatory Kentridge did not share. Soho appears no longer as the capitalist entrepreneur, but as a weakened and possibly contrite figure haunted by his past. After the collapse of his business empire in the preceding film, *Sobriety, Obesity and Growing Old* (1991), we find him comatose in a hospital hooked up to an oxygen mask and multiple obsolete-looking ultrasound monitors. Their imaging records his breathing and then suddenly screens deep memories from his past. Several doctors, all of them versions of himself, bend over the patient and let their stethoscopes examine his inside. In his delirium, images flash by from a journey by car, in which he witnessed murders and beatings at the side of the road, until he crashes into a man crossing the road who shatters the windshield. Clearly his unconscious is haunted by this past. Two motifs especially are linked to the theme of memory itself: one his intense look into the rearview mirror, the other the way in which the windshield wiper erases scenes of violence that the driver seeks to ignore (fig.15). Images from the drive alternate with images of Eckstein's inner organs on the hospital's monitors. Memories of his past generate the internal complaint of his inaction in the face of apartheid's violence. At the end of the film, a recovered Soho is briefly back at his desk surrounded by an old-fashioned cash register, rotary telephone, typewriter, ink blotter and hole punch, all of them instruments of colonial domination and control. Even if he were somewhat changed, he is clearly not free from his past.

Johannesburg's legacies of traumatic violence in the post-apartheid era are the theme of the other films as well. Kentridge's probing view of the South African transition jibes with his radical critique of the Truth and Reconciliation Commission (TRC) in his *mise en scène* of *Ubu and the Truth Commission* (1997), based on Alfred Jarry's political farce *Ubu Roi* (1896). The adaptation's use of documents from the proceedings of the TRC focused on the institutionalized hypocrisy of those confessions, which neatly discriminated

Fig.15　William Kentridge, drawing from the film
History of the Main Complaint (Eyes on Rearview Mirror), 1995–6
Charcoal and pastel on paper, 120 × 160 cm (47 ¼ × 63 in).
Tate

between perpetrators and victims. When, by contrast, Kentridge suggested that there is something of Ubu in all of us, his multiple selves assumed a clear-cut political dimension beyond individual psychology, especially in the series of drawings called *Ubu Tells the Truth* (1996), in which Kentridge represents his own body as Ubu's. The TRC lacked political recognition of the ways all white South Africans were implicated in, or benefitted from apartheid. Kentridge's work from the 1990s was a call for such recognition, for shouldering social responsibility in order to move forward.

<p style="text-align:center">✳</p>

Several of the early animation films already show large columns of marching people resonating with the eruption of the anti-apartheid movement into the streets in the late 1980s. The *Shadow Procession* of 1999, which emerged as a kind of residue of his political theater work on *Ubu and the Truth Commission* (1996–7), occupies a central place in Kentridge's oeuvre. The three distinct parts of the film were created as supplements for different scenes of the play's production.[14] And yet, the seven-minute-long tripartite film can be read as a work in its own right, illuminating Kentridge's philosophy of shadows so central to his memory art. Time and again later, he returned to the leitmotif of the procession, whether in lament as in *More Sweetly Play the Dance* (2015) or in celebratory exuberance as in *Refusal of Time* (2014) or in a counter-historicist mode as in his Rome project on the banks of the Tiber (see Chapter 3).

The silhouetted figures and objects making up this *Shadow Procession* were inspired by the puppet theater, specifically the puppets of Adrian Kohler with whose Handspring Puppet Company Kentridge had created the Ubu production. Here, of course, we do not have puppets, but two-dimensional flat figures, coarsely collaged out of scraps of thick black paper. Rivets and wire join their limbs and make them movable shot by shot (fig.16). Once projected as film, they feature those abrupt choppy movements that recall early cinema. Accompanied

Fig.16 William Kentridge, *Shadow Procession*, 1999
35 mm animated film, transferred to video and DVD, 7 mins

by emotionally loaded music, these monochrome black silhouettes first appear casting their shadows onto a grey blurry background but, in the third part, move in front of a brightly lit screen. The meaning of the procession is left open, as the spectator enjoys the compelling performance and struggles to comprehend this migration of people and objects. We know neither where they come from nor where they are going. Processions and marches always have a goal: the realm of the sacred or its secular equivalent such as the progress of society, the protest against injustice, or the migrant's search for a new home. Kentridge found it impossible to name a goal for the procession. Actually, he had planned another concluding part, which, however, resisted realization: 'I could not find it, not formally but intentionally. I could not find a destination [for the procession], neither a utopia nor a killing field. The fact of transition of movement was essential.'[15] And thus the procession simply peters out at the end. It never becomes clear whether its purpose is mourning, supplication, flight or protest.[16]

<p style="text-align:center">∗</p>

In a lecture of 2001 entitled 'In Praise of Shadows', Kentridge gave shadows an aesthetic and political validation that drew on Plato's cave parable. He asked whether the philosopher's trajectory from the darkness of the shadow world to the light of philosophical knowledge could not be meaningfully reversed: 'Can it work in reverse – someone blinded or bewildered by the brightness of the sun, unable to look at it, familiar with the everyday world and the surface, choosing to descend (not just for relief, but also for elucidation) to the world of shadows?'[17] In Plato, nothing much can be learned from the shadows. Kentridge disagrees: 'My interest in Plato is twofold: for his prescient description of our world of cinema – his description of a world of people bound to reality as mediated through a screen feels very contemporary – and, more particularly, in defense of shadows and what they can teach us about enlightenment.'[18]

For Kentridge, shadows have pedagogic and epistemological value. Rather than confronting us with transparent truth, they stimulate the visual imagination to fill in the gaps of that which is not visible or only barely, a process that can lead to productive ambiguity. In that way they teach us to negotiate the blind spots of vision and knowledge. Shadows promote a sensuous – that is, aesthetic – reflection about the practices of seeing and the inescapable dialectic of light and darkness, black and white. In his Harvard Norton lectures, Kentridge said:

> It's in the very limitation and leanness of shadows that we learn. In the gaps, in the leaps we have to make to complete an image, and in this we perform the generative act of constructing an image ... The very leanness of the illusion pushes us to complete the recognition and this prompts us into the very awareness of the activity itself. Recognizing in this activity our agency in seeing, our agency in apprehending the world.[19]

The production of images through shadow art is described here as a dialogic process that activates the spectator. The relationship of seeing to knowing is complex and never unequivocal, but the goal is always a worldly understanding. At the same time, this poetics of darkness and light resonates with the colonial construction of race with its hierarchy of white and black subtly reversed by Kentridge in his 'In Praise of Shadows'.

*

The medium of the shadow play thus functions like a visual concept metaphor both for Malani's and Kentridge's work. It embodies the fragile structure of memory itself as an inevitably shadowy repetition plagued by blind spots, traps, loops of emerging and vanishing images, compulsively grating or soothing incantation of words, music or sounds. It is the shadow play of memory itself, of history retold, of mythic stories or narratives with stock characters coming to life in

the memory culture of our times. In these works, Malani and Kentridge give us the shadows of time itself in their focus on discarded fragments of history, obsolete technologies, the detritus of culture and social life, the everyday of the subaltern. Rather than focusing on the unrepresentability and irrecuperability of human trauma, both artists stay with storytelling and with image-making, however fragmented and montaged their image worlds may appear. Only in visual and verbal storytelling, as it appears, vanishes and reappears again, is the continuity of life guaranteed. Storytelling is always both mythic and enlightening. There is no self-indulgent wallowing in the injuries of the past in these artists' aesthetic testimony about our world. The shadow play refers us to the twilight of cultural traditions within a now differentiated global modernity, their multiple routes of cross-cultural pollination, translation and appropriation. In their image-writing, Malani and Kentridge point to the continuing threats of voracious colonization, racial conflict, gender violence, colonial warfare and ecological destruction. At a time when destructive myths of national purity and cultural identity are experiencing an unexpected resurgence across the world, the need to hear Cassandra's voice, coming out of the shades, is ever more urgent. This is how both Malani's and Kentridge's aesthetic work points toward a horizon of expectation and challenges us to think and imagine alternative futures.

Traveling Trauma Tropes: Salcedo, *Atrabiliarios*, and Sundaram, *12 Bed Ward/ Trash/The Ascension of Marian Hussain*

Tropes and images of Holocaust discourse have appeared prominently in many public debates about historical violence and trauma in other parts of the world – from Latin America to Africa to South Asia. Their deployment is usually not meant to challenge the alleged uniqueness of the Holocaust nor to revel in memory competitions, but to deepen and shape a coming to terms with other instances of state violence, racism, colonialism and ethnic cleansing. Michael Rothberg has coined the term 'multidirectional memory' to describe such connectivities.[1] I prefer to speak of memory palimpsests and their multi-directional layerings that increasingly and powerfully address global concerns with violations of human rights.[2] Such memory palimpsests are central to many of the memory artists across the world. They are a key feature in several works by Doris Salcedo and Vivan Sundaram. Both artists are widely read in the literature about the 20th-century's catastrophes, with Salcedo's focus more on the poetics of memory (see her frequent use of Paul Celan) and Sundaram more engaged with theories of modernity such as Walter Benjamin's, adapted to a colonial and postcolonial context. This appropriation of the paradigmatic 20th-century catastrophe as metaphor permitted these artists to articulate local experiences of traumatic violence

in Colombia and India respectively without falling into the trap of claiming identity with the Holocaust.

A comparison of Salcedo's installation *Atrabiliarios* and Sundaram's *12 Bed Ward* shows that thematic affinity does not determine aesthetic strategies or their quite different modes of dealing with the politics of memory. Both works rely on the materiality of shoes and the absence of bodies to point to traumatic experiences, which are only evoked in their material residues. Similarly, when Salcedo subtly strung human hair across the kitchen table in *Unland: The Orphan's Tunic* (see Chapter 1, fig.5), drilling miniscule holes through the massive wooden surface, it was the fragility of the material residue of the human body rather than its appearance in heaps of shorn hair that determined her focus and aesthetic strategy. The violence of drilling hundreds of holes through the table to fix the hair compares with Sundaram's stringing together of hundreds of soles that had been cut off by knife from discarded shoes. In both cases, the mimesis of suffering evoked is exacerbated by the violence imposed on the materials.

We have all seen heaps of shoes, glasses and hair in Holocaust museums or in photographs, which remind us inevitably of images of the piles of dead skeletal bodies discovered in the camps in 1945 and powerfully documented in Alain Resnais's film *Night and Fog* (1955). Those heaps of shoes dramatize the ultimate de-individualization of mass death that corresponded to Nazi strategies to dehumanize their victims. When Salcedo and Sundaram pick up this motif, they inscribe it in a local context which powerfully transforms the image and its resonance. But it is not just the different historical context of violence and its remembrance that determines their use of the trope. Neither Salcedo in *Atrabiliarios* nor Sundaram in *12 Bed Ward* use amorphous piles of shoes, though Sundaram comes close to it in a brief sequence of the video *Tracking* (2003–4), which precedes his series *Trash* (2005–8). Salcedo, for sure, recognized that the mere accumulation of empirical matter might not enable the ability to mourn the loss of life. That is why she and Sundaram singularize their victims, either

individually or by the specific social group to which they belong: raped and murdered women, the mostly lower-caste homeless poor respectively. In that way, these artworks give the victims back their dignity, generate a critique of social oblivion and enable mourning. Salcedo's work refers to violence committed in her country's past and continuing in the present, while Sundaram's confronts us with the ongoing slow violence of abject poverty in the megalopolis of the Global South. Both artists demand a politics of memory that would intervene actively in the present.

<p style="text-align:center">∗</p>

Compared with the overwhelming and almost suffocating sculptures of *Casa Viuda* and the *Untitled* furniture series of the 1990s (see Chapter 2), *Atrabiliarios* (1991–6) is one of the most finely grained, minimalist works of haunting beauty that Salcedo has ever produced. The title is deliberately untranslatable, but it refers etymologically to mourning and simultaneously to rage. Like *Casa Viuda*, *Atrabiliarios* testifies to the grief of survivors, but it does so in significantly different ways (fig.17). All the spectator sees when entering the empty white box of the gallery is a discontinuously spaced frieze of small object-images running around the gallery walls at mid-height. As one approaches, one realizes that the frieze consists of a series of rectangular cut-outs of slightly differing sizes in the gallery walls. Each of these wood-framed niches contains a shoe or a pair of shoes. The shoes stand upright in the wooden box or lean against its back, heel up, as if balancing on the toes. They are mostly women's shoes, worn, but neither particularly stylish nor visibly work-related. The visibility of the shoes is blurred by semi-transparent animal fiber from dried and stretched cow bladder, stitched crudely with surgical thread into the surrounding plaster wall. The cow bladder, Salcedo suggests, points to the unsanitary conditions in which women were held captive; the crude surgical thread forcefully sutured into the wall reminds us of the closing of a wound.

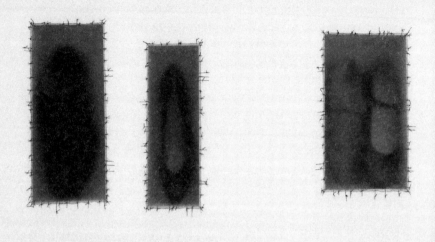

Fig.17 Doris Salcedo, *Atrabiliarios*, 1992–2004
Shoes, drywall, paint, wood, animal fiber and surgical thread
Overall dimensions variable
San Francisco Museum of Modern Art

At the same time, it is as if each shoe or pair of shoes were covered by a shroud, like a relic. One might think of Mediterranean burial practices such as *columbarios*. But the parallel fails. This work points to the absence of the body, the absence of a burial site, which the *columbario* still implies. The shoes are undoubtedly there, underneath the animal fiber, but they appear as if on old photographs, blurred, dimly visible, some resembling sepia photos or photos faded with time. The object salvaged from a mass grave, often the only forensic evidence to identify the victim, has become image. Seen from a distance, the stitches sewing the animal fiber to the gallery wall and the thin whitish frame of each niche vaguely resemble the frames of early photography. The enshrined relic as photo-graphic image shares the idea of absence and ultimately of death. Each image offers a still life, a singular *nature morte*. There is no narrative coherence in this series, just juxtaposition and an incomplete(able) archive of lost lives in a country oblivious to its losses. *Atrabiliarios* articulates not just the pain that comes with memory of each of the disappeared, but it draws our attention to the inaccessibility of that very memory as the bodies have disappeared and lack individual burial. The niches in the wall with their shoes are a mournful substitute for the proper burial denied.

We know that every one of Salcedo's works is based on close encounters with surviving victims of abuse and violence. In the late 1980s and early 1990s she traveled widely in Colombia, listening to horrendous stories mainly told by women survivors who lost husbands, brothers, fathers in the perennial armed conflict between the army, the guerrilla, the paramilitaries and the narco gangs. Witness testimony had of course played an ever-increasing role in the transnational memory discourses of the 1990s, especially in the wake of Claude Lanzmann's film *Shoah* (1985) and the establishment of the Fortunoff Archive of Holocaust Testimonies at Yale University (1981). It carried with it a promise of authenticity and documentary truth at a time when there were ever fewer aging survivors of the Holocaust. The fact that the poet Paul Celan, himself a Holocaust survivor,

appears in manifold guises in Salcedo's work shows that she
was very aware of that context. But rather than giving unalloyed
voice to the testimony she had listened to, she absorbed
the stories told, thus becoming a witness of the witness, a
witnessee, as it were. In a way she incorporated the grief of
the surviving witnesses by becoming herself a medium for the
pain and suffering of her interlocutors, with the artwork as an
embodiment of that social memory. Fully aware of the dangers
of voyeurism and facile compassion that always threaten public
confessions of individual suffering, she erased the particular
individual stories, arguing that for art to be, the stories must not
be told. Her art thus became an amplifier of the suffering that
has had Colombia collectively in its grip for decades. Paradox-
ically, its abstraction from particular cases is its affective
strength. In her demand for a collective ethics of mourning,
Salcedo developed an artistic vocabulary that created objects
and images, which rendered the singularity of each and every
act of violence. The violence itself is never shown, nor are the
perpetrators or victims. Bodies have disappeared and there is
no consolation of burial. The work is based on an aesthetics
of negativity, absence and grief. It is the pain of the survivors
that is made visible in the work, their attempt to come to terms
with life after trauma.

When pressed, Salcedo had a compelling story to tell about
the making of *Atrabiliarios.* It is the story of a woman guerrilla
who came back to Bogotá to celebrate the first communion of
her son. She was disappeared. A lawyer found out that the secret
services had captured her and raped her repeatedly. Eventually
that lawyer's dogged investigation identified her body by her
shoes in a mass grave. Having got close to the truth was a death
sentence. He, too, was killed soon thereafter. It was this singular
case that led to the shoe sculpture. In the first showing of
Atrabiliarios in 1991 at Boston's ICA, Salcedo used this guerilla
woman's shoes and others given to her by victims' families,
which she then returned after showing the work. Later she
used other shoes in new versions of the work, which was ideally
accompanied by large, closed boxes stored in a corner of the

gallery and covered with the same animal fiber. The content of these boxes was left to the viewers' imaginations. If indeed they contained more shoes, these shoes themselves were not visible, but the multiplicity of disappearances was registered together with the singularity of each and every shoe exhibited in the fragmentary frieze around the gallery wall. Absence and presence, visibility and invisibility penetrate each other in complex ways in this work, which, given its visual beauty and delicacy, is bound to leave the viewer in a melancholy and disturbed state of mind. If we read this work in relation to Holocaust tropes, the reading is belated, *nachträglich*, not even necessary to make sense of the work by itself. And yet it is significant that we cannot help but read it that way. Our transnational memory culture is saturated with Holocaust tropes and images, but simultaneously haunted by an inability to mourn and an unwillingness to remember. *Atrabiliarios* speaks both to the global spread of Holocaust tropes and imagery and to the moral danger of forgetting in our time.

*

At first sight, it seems that something similar can be said of Sundaram's installation *12 Bed Ward*, a work that was first made in 2005 for a show in Delhi and expanded three years later with other components for the show *Trash*. The artist, given his dual Hungarian and Indian descent, had visited Auschwitz in 1988 and it did not seem outlandish to frame the Indian Partition with its massive repressed violence in relation to Holocaust memory. The after-effects of the Partition in the anti-Muslim mob violence of 1992–3 had been the subject of Sundaram's *Memorial* (see Chapter 2). The analogy of German-Jewish relations to that between Hindus and Muslims in India has also been explored in works such as Anita Desai's novel *Baumgartner's Bombay* (1988). Yet the Holocaust effects as opposed to Holocaust representations are less pronounced here than in Salcedo's *Atrabiliarios*, and this is especially true if one considers the inclusion of *12 Bed Ward* in the later

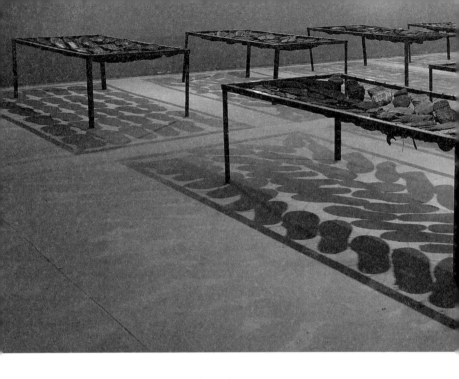

Fig.18 Vivan Sundaram, *12 Bed Ward*, 2005,
Installation view in *Urban Manners* exhibition
Steel, old shoes, string, wire, bulbs,
698.5 × 1206.5 × 398.75 cm (275 × 475 × 157 in)
Hangar Bicocca, Milan

Trash exhibit, which expands the theme of dispossession to the
slow violence of urban economics in the Southern megalopolis.[3]
These works collapse temporal distances between the catastro
phes of the 1940s and the present, evoking the long-term effects
of past violence in the present.

Sundaram leaves it deliberately unclear if his ward refers to
a detention camp, a tenement, an asylum, a prison or a hospital
ward. Does it shelter or endanger its absent sleepers? Twelve
metal bedframes are arranged in two neat rows. The room is
dark, lit only by naked bulbs hanging from long wires over each
of the bedframes. Bare bedframes and bare bulbs in a darkened
room make one think of bare life. But life is altogether absent
from this installation. A single black metal chair, also lit from

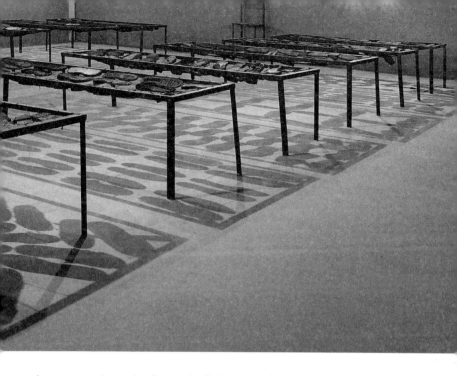

above, stands at the far end of the room between the two rows of beds, as if surveilling the implied but absent human bodies. The dim lighting, the wires, and the bulbs are reminiscent of some of the installations by French memory artist Christian Boltanski. But while Boltanski's work dealt, sometimes in deliberately ambiguous ways, with the archival traces of the Holocaust, Sundaram's *12 Bed Ward* conjures up abject poverty in the present (fig.18). Shoes are absent, or rather spectrally present with their residual soles only. Instead of a surface of wire coils that would support a mattress, Sundaram has strung together worn-down and often perforated soles of men's and women's shoes, roughly two to three dozen each per bedframe and arranged in different geometric patterns. There is no mattress here, just as there was no bedframe in Kuitca's installations (see Chapter 1). The shoes themselves have disappeared; their damaged soles, cut off by knife and resurrected for further use in an informal economy of waste, are the only residue here of human life. The light from the

bulbs casts shadows of those soles onto the naked floor of the room. The emotional effect of the installation largely results from the shadow play of light and darkness. The number of soles – real ones and their shadows – is in the hundreds, but the installation maintains a tension between each individual sole and its multiples: a cipher for mass poverty and dispossession rather than genocide. And yet, how can a visitor encountering *12 Bed Ward* not think of the piles of worn shoes, glasses, hair or discarded and battered suitcases known from the Holocaust? Resonances such as this one inscribe the work in a by now transnational, if not global, trajectory of memory art which, in form and in content, is transformed in such a way as to speak to its specific local context and conditions of production. Globalization, after all, connects and differentiates at the same time. Memory artworks such as this one have the ability to syncopate different histories of violence through aesthetic means, to suggest connections between the event that gave genocide its name and the slow violence of poverty and dispossession in the contemporary urban world of the Global South. In their mix of abstraction and emotion, they carry an affective politics that refuses sentimentality, voyeurism and inconsequential compassion. They offer *Denkbilder*, images that create thought, in a Benjaminian sense, which cut across national and political borders.

12 Bed Ward can stand alone as a powerful installation reminding us of confinement by poverty, a visual, Brechtian *Lehrstück* (learning play) about the poverty level of living space, as Sundaram might phrase it. But in the *Trash* exhibition of 2008, it was shown with two other works, which circumscribe and expand its range of meaning: the short video *The Brief Ascension of Marian Hussain* (2005) and the series of digitally composed photographs entitled *Trash* (2005–8), which in turn were accompanied by two more videos, *Tracking* and *Turning* (2008). Holocaust resonances vanish in these works, which foreground the contemporary reality of urban life in the megacities of the Southern hemisphere, its deprivations and dispossessions. Chaitanya Sambrani has persuasively spoken

of an anthropology of trash that underlies these videos as well as the large photographic images of his model trash city constructed in his studio.[4]

Memory of a different kind is inscribed in these projects, as they refer us back ironically to modern city planners such as Haussmann, Robert Moses, Corbusier and Lutyens. Sundaram's deployment of trash calls up images of the ragpicker in Baudelaire, Siegfried Kracauer's focus on urban detritus, and Benjamin's notion of collecting and obsolescence.[5] Key moments of an earlier metropolitan modernity in the West hover in the background of Sundaram's take on metropolitan reality in South Asia today. But the Baudelairean ragpicker and the artistic recycling of detritus by modernist artists like Duchamp, Schwitters or Rauschenberg is fundamentally different from Sundaram's practice in *Trash*. Sundaram does not allow for any nostalgic romanticization of the ragpicker figure, nor is his use of trash simply an avant-garde attack on high art. Instead Sundaram immersed himself in the informal economy of Delhi waste-picking and engaged a group of lower caste Delhi boys who made their living as waste-pickers, among them Marian Hussain, subject of the brief looped video projection *The Brief Ascension of Marian Hussain*. They worked with him to collect the mass of materials for the installation of his model trash city that became the subject of the large, wall-covering photographs of *Trash*.

Sundaram's engagement with trash displays his critical obsession with recycling, reinstalling, retaking, reenacting, which is one of the main threads of his aesthetic experimentation. But it also reflects the reality of the contemporary informal urban economies of the Global South, whether in India, Africa or Latin America. In *Trash*, it is discarded materials, the ephemerality of the everyday, the non-monumental dimensions of urban life, and the city's monumental production of garbage that are condensed in powerful images lacking any human presence. In its choice of materials, the temporary *Trash* installation that gave rise to the photographs provides a visual critique of capitalist consumer culture, which

invaded India with a vengeance after the collapse of the Soviet Union, the end of the Cold War and the quick fading of the non-aligned nations movement that had India as a central member ever since the Afro-Asian Bandung conference of 1955.

Sundaram's first venture into the detritus of the megalopolis was the circular floor sculpture *Great Indian Bazaar*, first exhibited at the Second Johannesburg Biennale of 1997, a beautiful work made up of 400 postcard-size photographs in identical red aluminum frames rising to a height of about 30 cm in the middle of the carefully circumscribed pile. The photographs represent an archive of Sundaram's snapshots of makeshift Delhi markets where vendors spread their goods on the pavement, often on a plastic sheet marking the boundary of their 'shop'. The photographs show neither genuine flea markets nor Oriental bazaars with exotic spices and colorful textiles. They represent accumulations of second-hand objects – old toothbrushes and combs, worn shoes, underwear, computer chips, an old sewing machine, things people have discarded, much of it already trash rather than commodity. On gallery walls nearby, silk-screened on offset printing plates, were statements by Indian economists about the globalizing consumer economy and its effects on 'third world' labor. For Sundaram, these pavement markets, part of a vibrant informal economy of waste, offer 'surreal collages' and represent 'reality at the poverty level of 'consumption'.[6] The ragpickers have vanished, present only in occasional traces such as a shadow or a pair of feet at the edge of the image. Or a pair of hands counting money as part of a transaction. Transaction and exchange were incorporated into the project. Spectators could pick freely and buy any one of these framed pictures for a minimal fee, thus eventually taking the sculpture apart. With this process, representations of the bazaar (exchange) became themselves a bazaar (exchange) of representations. But looked at from a distance and preserved now in installation photography, the work with its hundreds of uniform red metallic frames carefully arranged in a perfect circle exuded a strange beauty that clashed with the barrenness of its social content. Here too

the minimalist idea of a flat horizontal sculpture on the floor
à la Carl Andre is re-imagined with explicit indexical references
pertaining to the poverty level of urban social life. The
minimalism of art meets the minimalism of life in an economy
of waste. Minimalist sculpture and a specific urban reality
in the Indian megacity come together to comment forcefully,
if indirectly, on the full-blown neo-liberal marketization that
arrived in India with capitalist financialization after 1989.
Great Indian bazaar indeed!

A similar impetus lies behind the stunning photographs
of the *Trash* series, except that here the violence of urban
transformation itself becomes the subject in the creation of a
miniature city composed entirely of trash. In the construction
of this miniature city in his huge warehouse-like studio in
Delhi, Sundaram cooperated with Chintan, a local NGO trying
to create safe working conditions for waste pickers that would
protect them from health-threatening toxic fumes, garbage fires
and other dangerous conditions of recycling. Chintan provided
several truckloads of sorted garbage which Sundaram, with
his ragpicker assistant Marian and others, organized into
a vast floor sculpture that became the subject for the *Trash*
photographs. Towers made of cans stacked upon each other
or piled up blocks of compressed garbage figured as high-rise
buildings. Square cardboard boxes open to view from above
and filled with odds and ends were assembled to mark housing
blocks. There were highways, flyovers, drains and barricades,
all made from materials represented in the photos of *Great
Indian Bazaar,* such as discarded machine parts and used
tyres, pipes, bricks, wire, transistors, glass, cardboard, kitchen
utensils, collections of batteries and other electronic waste,
toothbrushes, cans, worn fabrics, torn mattresses, empty
perfume bottles, metal tubings, an old typewriter and
battered printer, etc. It was a Legoland of urban and domestic
waste (fig.19).

The horizontal layout of masses of discarded materials and
the centrality of photography gibes with *Great Indian Bazaar.*
But the enormous cityscape in miniature constructed in the

Fig.19 Vivan Sundaram, *Barricade (with Mattress)*, 2008
from *Trash* series
Digital print, 98.4 × 170.2 cm (38 × 67 in)

studio at a scale of 20 by 60 feet was not minimalist in any way. It was a maximalism of trash materials that simulated the density and clutter of urban space. A similar technique of excess and inundation, constructed in 25 carefully composed tableaux representing the making of modern Bengal, characterized the assemblage of historical materials in *History Project* (1998) (see Chapter 6). Here, the Bengal modernity of today appeared as flooded by a world of trash. The installation, however, which has not survived as such, was not the ultimate artistic goal. It was only a step to the large-scale, digitally manipulated photographs of the installation. It is as if the installation itself vanished into the photographs, mainly taken from an aerial perspective, which Sundaram had also privileged in his engine-oil paintings (see Chapter 2).

The monumentality of *Trash's* fake cityscapes and their organized chaos can be read in two registers. On the one hand it implies a retrospective critique of modernism's architectural phantasies of *tabula rasa* planning, present in Prime Minister Nehru's and Le Corbusier's vision of creating the paradigmatic modernist Indian city in Chandigarh. Building a city – even a miniature one – entirely from trash is a fundamentally contradictory enterprise. Cities are built to last. The city as such has a utopian dimension in that it resists the transience of all life. Building it from trash means building it from the essence of the transitory, the throw-away, the discarded, the detritus. Of course, we all know of the destruction of cities, their transformation into ruins which themselves often become signifiers of eternity. But building it from trash is an ultimate provocation, an assault on the very idea of the city itself. In that sense, Sundaram's maquette of trash city gives the lie to all of those earlier modernist utopias. The accompanying video, *Tracking*, with its nightmarish ominous darkness lit up only by a surveillance tracking light that scans the surface of the maquette, suggests that the dream has gone terribly wrong.

The memory register speaks loud and clear in this work, especially in the monumental mural photograph tellingly called *Master Plan*, for which 14 photographs of the maquette were

shot with a square camera from above and photoshopped to create a seamless picture. But the other register is that of the present: the drowning of the 21st-century megalopolis in the mass production of garbage and trash. Sundaram's 'poverty level of consumption' is coupled here to the results of neo-liberal globalization and its consumption frenzy. The disjunctures of urban space are emphasized in the *Trash* photographs entitled *Barricade with Two Drains* or *Barricade with Gutters* (both 2008). Barricades point to exclusionary spaces in the city, except that in Sundaram's work, the areas surrounding the barricade on either side are constructed out of the same discarded materials, whereas the real separations of urban space into gated communities and slums reflect the dystopia that Mike Davis, in his 2005 book, described as *Planet of Slums*.

At the same time, there is a countervailing aspect. This Legoland is wonderfully vibrant and heterogeneous in shapes and colors; the objects from which it is constructed entice the vision of the spectator; their materiality is all but erased by the smooth surface of the photograph; the closeness of the maquette to miniature playlands is obvious. The exuberance of colorful materials comes to life in the video *The Brief Ascension of Marian Hussain*, a kind of coda to Sundaram's treatment of subaltern life in the megalopolis. Sundaram had actually hired the boy Marian as an assistant and as part of his waste-picker brigade that participated in the gathering of materials and their arrangement into the miniature city in the artist's studio. The video shows a human figure asleep on a foam mattress atop a mountain of trash. He wakes up, stretches his young and vigorous body and leaps ballet-like into the air as if to fly away, with his feet and legs dangling from the top frame of the image. Rather than an escapist phantasy it is a fictional moment of utopian hope in a world circumscribed by the toxic reality of waste picking and recycling. If *Trash* points to the failure of modernization and the 'unfulfilled social promises of the postcolonial nation-state', the still with Hussain's body elegantly suspended in the air gives some hope for the future.[7]

Dispossession and hope are presented by a singular named human being, the only human in this intermedial show that brought together *12 Bed Ward*, *Trash* and *The Brief Ascension of Marian Hussain*.

The ascension is indeed brief and the dissonant mechanical soundtrack warns us that there is no redemption to be found here, just fleeting moments of hope that the dispossessed cannot live without. A decade and more later, in the midst of Narendra Modi's right-wing neo-liberal and anti-Muslim government, the situation of Delhi's waste pickers and their informal economy has got worse. Their only daily income garnered by recycling waste is now threatened by the increasing privatization of the garbage-removal industry. The moment of hope has been erased for these Dalit waste pickers whose livelihood depended on manual recycling.

No coincidence then that in the end the installation itself was taken down, its dismantling evoked in the video *Turning*. This is where a dystopian reality intervenes, the dystopia of a surplus humanity that itself seems destined to become trash in a world run by hyper-capitalism. Both Salcedo and Sundaram, socially aware and cognizant of the problematic figure of the lone artist creating their work, have engaged in collaborations with the subjects of violence and dispossession which their works speak of: Salcedo in her role as witness of witnesses' accounts and especially in collaboration with the group of women rape victims in the creation of Fragmentos (see Chapter 7); Sundaram in his collaboration with waste pickers from the lowest caste. Their approach to politics and aesthetic materials created acts of memory addressed to both national and international audiences. Their collaborations stimulate hope for alternative futures, but such hope seems to have been dashed for now in both cases by the rise of right-wing political reaction, both in their countries and in the world at large.

Re-coding Museum Space: Salcedo, *Shibboleth* and Sundaram, *History Project*

Museums were founded in 19th-century Europe to preserve and showcase the treasures of human cultures and to highlight national traditions. More than just sites of preservation and education, museums constructed encompassing narratives that shaped Western universalism, as seen in universal survey museums like the Louvre, the British Museum or The Metropolitan Museum of Art. National history museums created national traditions, and natural history museums presented colonized 'primitive peoples' and their culture together with animals and plant life. An ideology of progress, most evident perhaps in technology and science museums, underlay all these efforts to secure various pasts and to transmit them to future generations. The museum became the paradigmatic institution of cultural memory. And as all memory, it was always riddled with forgetting.

Like the discovery of history itself, in its emphatic modern sense with Vico, Voltaire and Herder, the museum was a direct effect of modernization's temporal and spatial regime. It has stood in the dead eye of the storm of progress, serving as a catalyst for the articulation of tradition and nation, and it has provided master maps for the construction of cultural canons. It defined the identity of Western civilization by drawing external and internal boundaries that relied as much on exclusions and marginalizations as it celebrated cultural achievements. The superiority of the West was taken for granted

in the conflictual dialectic between modernity and the simultaneous down-grading of the primitive and other cultures.

At the same time, museums have always been attacked as agents of cultural ossification by all those speaking in the name of life and cultural renewal against the dead weight of the past. Such attacks, however, were themselves predicated on the privileging of the new. It seems clear that the borders separating the past from the present were much stronger at a time when the ideology of progress still held sway. The old had to make way for the new. But as the idea of unlimited progress has increasingly lost its power to persuade, reflection has turned backwards, making the present more porous to the past. This is where a new critique of the museum as an institution of memory has emerged. Historical revisionism has produced critical accounts of universal and national master-narratives and their implication in domination, dispossession and conquest. In this context, the active participation of museums in colonial regimes and the looting of conquered and dominated cultures has become a major issue in recent years. In the United States, public critique has zeroed in not only on the corporate donor regime of museums, but also on curatorial practices as paradigmatically articulated by the activists of the 'Decolonize This Place' movement. Walter Benjamin's pithy saying that there is no document of civilization that is not at the same time a document of barbarism describes a stubborn dialectic that cannot be dissolved or overcome in some reconciliation.

This new critique of the museum, which has forerunners both in the European historical avant-garde and in the institutional critique of the 1970s (in the work of artists such as Hans Haacke or Martha Rosler), has inspired artists to develop artistic projects that problematize the museum itself as institution. As with public art in urban space (see Chapter 3), it has been installation as a medium that has proven its power to make museum space transparent to immanent critique from a postcolonial perspective. This chapter juxtaposes two projects that could not be more different. Both, however, re-coded

a monumental institution in the museum world for a limited period of time. Doris Salcedo transformed Tate Modern in London, a Western museum of international modern and contemporary art; and Vivan Sundaram re-coded the Victoria Memorial Hall in Kolkata, a colonial building dedicated to the memory of Queen Victoria, Queen of the United Kingdom and Empress of India. Tate Modern is itself already a re-functioned industrial power station (formerly known as Bankside) on the banks of the Thames, built in the immediate post-World War II era and decommissioned in 1981. The Victoria Memorial is a huge rectangular fortress-like complex with a giant cupola in the center and ornamental towers at the four corners, built in the style of colonial Indo-Gothic architecture, a hybrid revivalist style which British architects in India privileged in the early 20th century. As a celebratory memorial to the British crown and the colonial enterprise, it also stands today as an abandoned emblem of former British rule in India, just as the shell of the Bankside power station stands as a remnant of the industrial age. Both buildings have themselves become sites of heritage culture. Both artists articulate an alternative memory from an elsewhere space in the Global South, different from that of Western modernism or European colonialism. They do it in aesthetically very different ways, but it is the mode of (post)modernist installation art that makes them comparable.

*

Salcedo's *Shibboleth* was the 2007 showpiece of Tate Modern's Unilever Series, an annual commission that invites one artist per year to create a major work to be displayed in the museum's cavernous empty space that once housed the giant turbines of the power station. As many other monuments of the second industrial revolution, the building had been transformed into a museum in the 1990s by the Swiss architects Herzog & de Meuron. Most of the external appearance of the power station was preserved, including the slick brick facades and the almost 100-meter-high chimney overlooking the Millennium Bridge

and competing with St Paul's Cathedral on the other side of the river. Also left largely intact was the huge Turbine Hall inside with its gently sloping surface downward from the entrance and extending to the far other end of the building. It is the *pièce de resistance* of the building. The Swiss architects' minimalist design proved to be a perfect match for Salcedo's complex minimalist installation.

Site-specificity was key to Salcedo's project. Overcoming persistent opposition by some museum officials, Salcedo's team removed a 167-meter-long corridor of 5 × 5 m concrete slabs from the Turbine Hall's floor. Into this trench she inserted the V-shaped structure of the meandering – at points widening, at others bifurcating or narrowing – crevice that had been constructed in its entirety in Salcedo's Bogotá studio (fig.20). The process, involving molds and chainlink fence imprints in the concrete walls of the V-shape crevice, was incredibly complex. Given its weight, the V-shape itself was secured at the bottom with six-meter-long steel beams. Given the ragged edges of the crevice, hand carved with dental drills, new concrete had to be cast to fill the gap between the crevice and the adjacent slab. Salcedo hand-painted the new concrete so that, visually, it would all merge seamlessly. It was a perfect simulation that confused viewers who tried to figure out how the work had been constructed.

Visitors entering the museum and facing the 200-meter-long empty space had their gaze drawn down to the floor, if only so as not to step into the crevice which threatened from below and extended in snaking or zigzagging lines all the way to the far end of the building. If Gordon Matta-Clark in the 1970s cut and split houses in his anarchitectural experiments, Salcedo split in two one of the major sites of contemporary art in Europe. Her work violated the very foundation of the building, though never threatening its stability. Rather than creating a sculptural installation rising from the floor, as other artists in the series had done, her work went below the surface into the foundation. This gesture was more than merely an architectural challenge to a major European museum.

Fig.20 Doris Salcedo, *Shibboleth*, 2007
Installation at Tate Modern Turbine Hall,
London, 9 October 2007–6 April 2008
Concrete and metal, length 167 m (548 ft)

It sculpted the underground, thus revealing what underlay the museum.

The work's title, which goes back to an essay by Jacques Derrida on Paul Celan, gives a clue. Shibboleth is the biblical word from the Book of Judges 12 that cannot be pronounced correctly by members of the tribe of Ephraim who, defeated by the tribe of Gilead, tried to sneak back across the Jordan river into their home territory, which had been conquered by the Gileadites. When they failed the linguistic test of belonging, they were executed upon arrival. With 42,000 dead, this is the largest massacre described in the Bible. Transcribed into Tate Modern's floor, the idea of a shibboleth as a language test to prove belonging points to the exclusion of migrants who are deemed not to belong. The contemporary analogy is obvious, but it reaches way back in European history and its colonial expansion. The theme of immigration as exclusion and denial of rights as fundamental contradiction within Western universalism emerges powerfully from the meandering fissure that had visitors transfixed as they followed its path from the hairline crack near the entrance to expanding areas toward the other end of the crevice. Like a wound in the museum's ground, it made spectators reflect on racial hatred toward unwanted migrants, which has become ever more exacerbated in the age of Brexit and the rise of 21st-century fascisms across the world. This work did not simply illustrate the biblical story. Instead, it marked a gaping wound in the very constitution of European culture. In an overdetermined metaphorical fashion, it referred its spectators to the borders of Europe itself and what lies beyond them. It was one of the first major artworks that coupled memory culture and its concern with past injustice – the reference to the Bible – with the contemporary issue of unwanted migration. As always, Salcedo had done her research. She had not only looked into the history of Sir Henry Tate who had made his fortune with slave labor on his Caribbean sugar plantations; she had also researched one of the flash points of the current African migration to Europe – the heavily fortified Spanish enclaves of Ceuta and Melilla in Morocco. But the

constitutive racism of both, colonial and contemporary, is captured from a postcolonial perspective in this abstract, yet deeply affective, minimalist floor sculpture.

To many spectators, the meaning of the title in relation to the crack in the foundation was not immediately evident. To become fully aware required active looking, thinking and engagement on the part of the public. Spectators had to engage with the work from up close. Seen from a distance, there was simply a crack in the floor requiring care when walking, though not endangering visitors crossing it. It looked as if an earthquake had hit Tate Modern leaving this fracture in the ground. But as one followed the path of the crack, the meticulous sculpting of the crevice's inside walls proved to be a lure that drew spectators in, had them kneel down and explore the sculpted sides of the crevice, touch them by hand, wonder about their detail and delicacy. The work of the sculptor Salcedo became visible only in a close-up view of the crevice. As in the case of *The Orphan's Tunic* (see Chapter 1, fig.4), the dialectic of distance and proximity in reception worked here as well. Inserted into the concrete walls of the crevice and only perceptible once you bent over the crack was the wire-mesh of today's border fortifications in Israel, Hungary or the Mexico-United States border. The sculptural cavity became readable as a negative space of everything that has been excluded from Western culture, banned and hidden underground. The fracture in the floor exposed the dialectic of modernity, the dark side of the exclusions that have always grounded modernity's professed universalism.

Other works by Salcedo, such as *Palimpsesto* (2017), which addresses the fate of refugees drowned in the Mediterranean, share with *Shibboleth* the incredible complexity of planning, research and construction, which is ultimately hidden from our view.[1] Clearly, the artist does not want her audience to get sidetracked by merely technical questions. She wants our attention to be directed to the slow process of cognition through emotional affect. In an interview about *Shibboleth*, Salcedo said: 'It represents borders, the experience of immigrants, the

experience of segregation, the experience of racial hatred. It is the experience of a Third World person coming into the heart of Europe. For example, the space, which illegal immigrants occupy, is a negative space. And so this piece is a negative space.'[2] I take it that this unusually direct political statement was due to the many attempts by a Tate curator to stop the project, even at a time when the V-shaped blocks were already being shipped from Colombia to London. Salcedo almost buckled under the responsibility that came with being not only the first non-white artist, but the first woman from the Global South to have been invited to participate in the Tate's Unilever Series, a showpiece in this center of contemporary art and (post)imperial power.

Negative space it is indeed, but the negativity is overdetermined. The fissure in the ground reverberates not only socially in relation to migration from the Global South. As a mark in a museum of modern art, it also points to an analogous structure of exclusion in the canonization of modern art itself. It conjures up a history of European modernism, which until very recently has refused to acknowledge modernisms in Africa, Asia, and Latin America. It is part of a larger struggle for recognition by artists from the Global South not to be dismissed as derivative, but rather acknowledged in their creative attempt at a reverse appropriation of 'Western' modes of aesthetic expression. In 1989, British artist and curator Rasheed Araeen had first critically pointed to this bias in Western modernism with his London show at the Hayward Gallery called *The Other Story* and with his theoretical art journal *Third Text*, founded in 1987. Salcedo tells that other story in the medium of sculptural installation. *Shibboleth* marks the general fault line between the Northern and Southern hemispheres that still haunts our postcolonial colonial present. It reflects in powerful visual and architectural language on the continuities between colonialism, racism and immigration in politics and aesthetics. What better place to do this than that major London museum of contemporary art on the banks of the River Thames?

Today the crevices are no longer there. They have been filled with cement. But the outline of the crack is still visible all along the Turbine Hall. It is like a scar of the wound Salcedo had inflicted on Tate Modern, a wound, however, that for centuries has been a wound in the constitution of Europe itself. The affective power of this project has not diminished since the crevice itself has been filled, leaving only its outline intact as a trace. The message lingers thanks to the visibility of the scar and the visual documentation of this aesthetically powerful installation.

<p style="text-align:center">∗</p>

Where Salcedo used the aesthetic power of minimalist sculpture to articulate a complex critique of a politics of exclusion governing Western culture, Vivan Sundaram, an artist who had paid significant tribute to minimalism in his own earlier work (see Chapter 2), took the opposite tack. He deployed a maximalism of archival materials, texts, images and personal memories to invert the meaning of a major memorial site, the Victoria Memorial Hall in Kolkata (the capital of the Indian state of West Bengal). Both artists operated from a postcolonial perspective, thus refocusing the 1970s institutional critique of the museum, which had ignored issues of colonialism in the constitution of the museum itself. If Salcedo's work destabilized the foundation of a major Western art museum, Sundaram's project problematized a museal site dedicated to the commemoration of the colonizer herself.

In late 1998, Sundaram expanded the archival dimension of his work to address that major site of British imperialism in India. His *History Project* transformed a monument to colonial rule into a site of alternative history seen through the lens of memory. The Victoria Memorial Hall, conceptualized by George Curzon, Viceroy of India, was built from 1906–21, and is still today a major tourist attraction. Lord Curzon had called for a building 'stately, spacious, monumental, and grand', where 'all classes will learn the lessons of history'.[3] Over the course

of one year, Sundaram constructed a temporary installation in the museum's spacious Durbar Hall. Given that the installation was to mark the 50th anniversary of India's independence from British rule, it was bound to give us a counter-lesson of the history Lord Curzon had in mind. Indeed, Sundaram's thoughtfully selected materials for the installation re-coded the colonial building into a counter-monument by inverting its inherent colonial meanings from his perspective of the post-independence secular Indian state and his own commitment to an enlightened urban modernity. Assembling a wealth of media and objects, he created an open-ended archive of Bengal history and its struggles for modernity, focusing on industrialization from the mid-19th to the mid-20th century, on working-class and peasant anti-colonial uprisings as well as on classically modern Bengali culture (fig.21). As the spine of his installation, he inserted a railroad track traversing the main hall, suggesting 19th-century modernization under British rule, with an ominous thick rope hanging from above; a railroad wagon ironically equipped with rubber tyres, rubber being a major product of India; a trolley, loaded with a metal boat; piles of jute bags, each inscribed with dates from workers' and peasants' uprisings (jute being a vegetable fiber key to the Indian textile industry); a library of folders representing rebels against colonialism and the struggle for a Bengal modernity up until the chaotic end of colonialism; quotes by classical Bengali writers such as Rabindranath Tagore written into the cupola of the massive building; a 19th-century printing press conjuring up the production of 'seditious' anti-colonial newspapers and literature; plus cabinets and vitrines filled with photographs and audio visual materials. One could get lost here in endless discussion of the 25 tableaux documenting the making of modern Bengal.

One exhibit was especially telling. A large glass-encased box contained a two-step pedestal covered in blue velvet with a red plastic garden chair placed on its top. Gazing into the glass box, toward the eye-catching red throne, one noticed a barely legible image of Queen Victoria imprinted on the glass. It was based on an enlarged photograph of the monumental

Fig.21 Vivan Sundaram, *The History Project*, 1998
Installation
Victoria Memorial Hall, Kolkata

statue erected outside on the lawns of the memorial. Glass box, faded and ghostly photographic image, and red anti-throne were enough to carry the satirical take on British royalty and colonial rule, which still haunts India. This effect was heightened by the fact that the four glass panes encasing the box were framed by four sturdy gilded picture frames whose solid look stood in sharp contrast to the shadowy image of imperial glory and the blood-red garden chair throne.

History Project, one might say, was about Bengal modernity and its fragments. Collaboratively constructed with a team of workers, intellectuals, curators and historians over one whole year, it was a temporary installation like Salcedo's in Tate Modern. With its montage and bricolage, it resonated with the title and substance of Indian political scientist Partha Chatterjee's work on the contradictions of Indian nationalism in his book *The Nation and Its Fragments* (1993), a nationalism that first developed under colonial rule. Together with his team, Sundaram constructed his own open-ended museal counter-archive that spoke both to the fragility of memory and to the desire to construct an overarching historical narrative. Thus, it was not just about Bengal, but about the fractured construction of historical memory in a postcolonial context.

Fragmentation, of course, has a long and rich history in the arts. Geeta Kapur, author of a seminal book on modernism in India, has documented the orbit of art movements that Sundaram appropriated and transformed in his work.[4] These include Soviet constructivism, American minimalism, Italian Arte Povera and, ultimately, the global vocabulary of instal-lation art. Sundaram's deliberate misuse of the minimalist aesthetic is significant for this comparison with Salcedo. After an initial critique of minimalism, Sundaram came to appreciate its ability to drain objects of their authorial implications and to present them in their sheer materiality. It is in the nature of his selected objects that Sundaram differs from American minimalists like Carl Andre or Richard Serra. The objects displayed in his installation are historical and archival. With their patina of obsolescence, they risk recreating an auratic or

nostalgic dimension for the viewer. Critics thus accused him of nostalgia for Bengal modernity. But even if the objects qua object (the printing press, the quotes from major writers) may suggest an aura, *History Project* as a whole undermines any sense of nostalgia. The paradox consists in the fact that the authorial gesture, avoided in the archival *objet trouvé,* returns powerfully in the overall narrative, which offers a palimpsest of memories and deliberately avoids coalescing into some coherent whole for the spectator. The reproach, voiced by some of his Indian critics, that the post-independence artist fails 'to achieve a historically authentic oeuvre' is as misplaced as the accusation of nostalgia for a golden age of Bengali middle-class modernity.[5] It is misplaced since it does not account for the aesthetic structure of a work that draws its power from the confrontation of history with memory and its erasures.

The overall purpose of this re-functioning of the Victoria Memorial is clear. Anti-colonial history is powerfully inscribed into this counter-memory project. Struggles of peasants and the subaltern are recognized together with the march of industrial progress. At the same time, the very site of the installation points to a fascinating political equivocation between an approving recognition of Bengal modernity and a critique of its inevitable continuities with colonialism. This becomes quite clear in the video produced to document the work for its afterlife. The beginning sequence shows the piece of railroad track penetrating the length of the Memorial's center aisle ending in a buffer stop. The video's female voice-over sets the tone for Sundaram's approach to modernity: 'If, for Marx, the concept metaphor for history was a locomotive, then we cannot forget Walter Benjamin's sardonic afterthought that history is not so much a train ride, but grabbing the emergency brake.' The nostalgia critique is inattentive to this aesthetic and conceptual dimension of the work and to its site specificity inside a colonial monument. The buffer stop and grabbing the emergency brake pointedly gesture toward the invasion of unfettered capital into India in the wake of the fall of the Berlin Wall (1989) and the subsequent collapse of the Soviet Union.

Of course Sundaram very consciously opened himself up to such critical questioning. His own struggle with this issue becomes evident with the original title of the work, *Journey Towards Freedom: Modern Bengal*, which seemed to propose some journey toward an enlightened modernity not contaminated by colonialism. *History Project*, by contrast, refuses such confidence. It does not give answers, but raises questions in its spatialization of memory, leaving room for the spectators to interpret the ambiguities of Indian modernity then and now.

Both *Shibboleth* and *History Project* move along the edge of intelligibility, and deliberately so. They challenge the spectator's experience, which is slowly constructed in reflection on the riddles the works contain. Despite their different handling of time and space, both Salcedo and Sundaram produce acts of memory enabling affect and demanding cognitive and aesthetic participation of their visitors. Such art installations may or may not change politics in a narrower sense, but they certainly create a significant public space for what one might call an affective politics of memory emerging from a highly political aesthetic practice.

Memory Museums: Santiago de Chile's Museo de la Memoria y los Derechos Humanos and Bogotá's Fragmentos

In the wake of the cultural memory boom of the past few decades, a new kind of museum has emerged. It is dedicated to the documentation and memory of recent histories of state violence and trauma. Its focus is primarily on specific national cases, but it frames its mission as nurturing worldwide human rights. The national and the universal are thus in constitutive tension in such Museums of Memory.[1] Two such recently created institutions are the Museo de la Memoria y los Derechos Humanos in Santiago de Chile and Fragmentos in Bogotá. They differ in scale, but they share a commitment to the visual arts as a key component of their exhibitionary and educational activities. Their architecture and design speak in multiple ways to the problematic nature of memory and forgetting, history and politics.

The Santiago Museum, designed by Estúdio América, a group of architects from São Paulo (Mario Figueroa, Lucas Fehr and Carlos Dias), is located prominently in a large open space near the city center. Approaching it, one first sees a monumentally elongated rectangular glass and steel structure rising out of two reflecting pools and floating like an ark on two concrete bases above the Explanada de la Memoria, an esplanade extending on either side of the building with

a sloping descent from street level toward the entrance right underneath the body of the museum. The glass facades are coated with a thin copper mesh, which makes the museum look impenetrable from the outside while providing luminosity and transparency inside. Copper is of course Chile's major national resource, nationalized in the 1970s under President Allende and historically tied to Chilean national identity. Architecturally, this contrast of opaqueness on the outside and transparency on the inside marks the tension between the accessibility and inaccessibility of a traumatic past. The facades are crisscrossed by diagonal metal bars, creating irregular patterns. When at night enlarged images of the disappeared are projected onto the facade of the museum, the faces look as if crossed out by the diagonal bars. This spectral appearance points to the close link between the architecture and the performative dimension of memory that the museum embodies. The same is true of the wide, open outside space of the Explanada de la Memoria, which is an integral part of the museum's design. The Explanada is framed by terraced steps on either side, and it has been used for concerts, art exhibits and public events. It dominates the approach to the museum and serves as a space for the performance of memory, the live present-day supplement of the objects and archives within.

Fragmentos: Espacio de Arte y Memoria is located on a bustling Bogotá street leading straight to the Presidential Palace, City Hall and several ministries just a few blocks away. Its politically charged location is contradicted by its counter-monumental external appearance, a significant contrast with the Santiago museum. As one approaches, all one sees is a whitewashed wall with the letters F R A G M E N T O S cut through it, as if to allow the space to breathe. The entrance, preserved from an old colonial building that had fallen into ruin, is framed by its original ocher stone columns. The old house number 544 from colonial times is still visible right next to the current street number 6b–30 on Carrera 7.

Much smaller in scale than the Santiago museum, it contains neither historical exhibits nor major documentary

archives. Its work of memory relies entirely on the arts, an indicator of the absence of robust public memory debates in Colombia as compared with Chile or Argentina. Fragmentos is itself a work of art, an architectural marvel, an exhibition space and a public 'act of memory', a term Salcedo has used to characterize all of her work.

Both the Santiago museum and Fragmentos are sites dedicated to the memory of political violence and its overcoming: the human rights violations and state terror perpetrated in Chile during the military dictatorship of General Augusto Pinochet between 1973 and 1990 and the decades-long Colombian civil war. Both sites include spaces dedicated to the arts and public events. But their most salient common aspect is the fact that in a mostly male-dominated museum world, both were created by women who always suffer most from gender-based sexual violence in armed conflicts and under state terror. Both projects faced many practical and political odds before being realized, and both still face political antagonism and threats to their sustainability. This is the story to be told.

<p style="text-align:center">∗</p>

The Santiago museum was the official government-sponsored product of a spluttering process of the Chilean transition to democracy that began with the election of 1990 and resulted in the 20-year long coalition of a center-left government, the *Concertación*. For more than a dozen years, the official memory narrative of the transition reveled in pious calls for consensus, moderation and reconciliation, thus disabling any conflictual memory that would acknowledge the traumatic recollections of the military dictatorship, its convulsions and resurgences, its gaps and leakages that pertained not just to the dictatorship's victims, but to Chilean society as a whole.[2] The 1990s were a decade in which repression, denial and silence still prevailed, but small organizations of family members of *desaparecidos* created memorials, sites of conscience and commemorative plaques all across the country. Torture

centers in Santiago, like Villa Grimaldi or Londres 38, were declared sites of memory in 1994 and 2005 respectively, but many other memorial sites remained largely out of public view. It was especially the two Truth Commission reports, the Rettig Report of 1991 and the Valech Report of 2004, which laid the ground for a process that allowed documented memory and truth to coalesce and eventually be represented in the Museo de la Memoria y los Derechos Humanos.

It is symptomatic, however, that one of the major public memorials created in those years was the 2008 memorial in Santiago to Senator Jaime Guzmán, ideological leader of the nationalist right wing, who had been assassinated by a left-wing group in 1991. Recognition of state terror, let alone reconciliation and consensus in the post-dictatorship years was still hard to come by. The wounds were too fresh and the nationalist right wing too strong in its conviction that Pinochet had saved the nation from communism. It was only in the years after the arrest of Pinochet in London in 1998, and the diminishing influence of the military on public affairs, that the struggle of victims' families began to break through the collective resistance to memory.

Things changed during the Presidency of Michelle Bachelet (2006–10), who was the driving force behind the creation of the museum, designed and built in record time. Indeed, it is hard to overestimate the role of Bachelet and a group of women politicians she had charged with the development of the museum, all of them, like Bachelet herself, at one time imprisoned, tortured or exiled during the dictatorship. They publicly embodied victimhood, but at the same time symbolized a national recognition of the dictatorship's crimes. The museum was inaugurated in January 2010 by Bachelet herself at the tail end of her term as president.[3]

Visitors enter the Santiago museum itself through the base, after having passed a wall on the way down along the ramp inscribed with the Universal Declaration of Human Rights (fig.22). In the entrance hall they confront a huge map featuring the worldwide sites of truth commissions. It is accompanied by

Fig.22 Museo de la Memoria y los Derechos Humanos/
Museum of Memory and Human Rights, Santiago de Chile
Exterior view

a stone sculpture on the floor representing the elongated map of Chile with markers of the growing number of sites of memory across the country. The course of the exhibition then leads visitors from visual and audio documentation of the military coup of 11 September 1973 (the bombing of the presidential palace and President Allende's last radio speech) to exhibits documenting the installation of the military dictatorship, its practices of torture and disappearances, the media propaganda hiding the criminal practices of the DINA (secret police) and other security agencies. But the exhibits also include practices of resistance such as those by secular and religious agencies, major protest demonstrations in the 1980s by students and workers, the activities of religious resistance groups and the organization of political groups, all of which led to the resounding 'NO' to the continuation of military rule in the plebiscite of 1988 that initiated the renewal of Chilean democracy. The endpoint of the exhibition's trajectory takes the visitor to images from the National Stadium, site of the first mass detention in 1973, where President Aylwin in 1990 gave a highly symbolic speech that publicly recognized the fate of those detained, tortured and disappeared as moral ground for the new democratic government.

Visual and audio testimonies dominate throughout. It is especially the recorded personal testimony of torture that visitors will hear while looking at a metal bed attached to a machine used to administer electric shocks. Located in the only dark room clad entirely in black, this audio-visual documentation leaves an indelible imprint in the imagination of visitors of the body in extreme pain. At the same time, it raises all the well-known questions about the risk of fetishizing pain by placing such torture in a dark past that has allegedly been overcome. The focus on the experience of torture certainly risks blocking out the political function of terror. But it is the articulation of individual and always singular experiences that in their accumulation renders something essential about the dictatorship's dependence on terror. It does not reduce history to subjective testimony, as critics would claim. The multiplicity

of singular experiences conveys an objective reality. It does offer historical proof.

A key exhibit in the center of the museum is a wall with photos of the disappeared that reaches from the bottom to the top of the building. Across from it, at mid-height, a glass-walled platform extends from the second of three floors of exhibits, hovering in mid-air, permitting a comprehensive view, though from a distance, up and down the wall of images. On an interactive screen in the middle of the platform, viewers can access the biographies and circumstances of detention, death or disappearance of the victims. Empty black and white frames in the wall of photos are reserved for future additions as documentation becomes available.

A final room, the Hall of Nunca Más ('Never Again'), offers a space of reflection on the indispensability of human rights in the future of Chilean democracy. With an ever-expanding accumulation of data pertaining to post-dictatorship judicial trials and the enforcement of accountability, it offers insight into Chile's often stumbling attempt to work through its historical trauma, its eruptions of memory, frustrations of failing indictments, and lingering gaps of knowledge and information about the past. Needless to say, the museum stores not just the archives of the various Truth Commissions, but various other archives pertaining to the period of dictatorship and made accessible for public usage. The process of archiving is still an open-ended task.

The exhibit that best embodies the museum's commitment to the intersection of documentation and the arts is Alfredo Jaar's stunning *Geometry of Conscience* (2010), a permanent art installation located tomb-like underneath the Explanada de la Memoria. Steps lead downwards to a locked glass door that will open for a limited number of visitors at a time. As one enters a small chamber, another door will close behind, and visitors are immersed in three minutes of total darkness causing discomfort. Suddenly, a brightly lit, almost blinding, geometric pattern of silhouettes appears, 500 in all. They are extended to infinity by two large mirrors placed on opposite sides of the

chamber. After a while, the lit silhouettes dim and darkness again envelops the viewer. But the afterimage of the silhouettes is imprinted on the brain as the metal door opens behind and one climbs the steps to the Explanada and daylight (fig.23).

By creating a rectangular, linear pattern of silhouettes, Jaar's work responds creatively to the museum's architecture and its museography. His design counters the irregular geometric patterns of the facades and his use of mere silhouettes responds to the photo installation in the museum. These silhouettes may appear anonymous, but they are not. Half of them are taken from images of victims, the other half use silhouettes of Chileans who are still alive. Abstract as it is, the work powerfully suggests the massive collective loss to Chilean society as a whole, the dead and the living, a loss that extends beyond individual survivors' stories toward the violation of all citizens' human rights. It thus poses a task of collective conscience for the future, opening up an entirely different dimension of empathic affect and visceral understanding of the collective past.

This task is addressed by the performative dimension of the museum's projects of lecture events, guided tours and temporary art exhibits. Exhibits both outside and inside the museum have included Chilean and international artists' work on issues of political violence and human rights. Coupling a permanent museal exhibition with live art exhibits may indeed help prevent museal objects from being reified. It nurtures active reflection and public discourse about memory in its intersection with the interpretive endeavors of contemporary post-dictatorship artists. If the danger of traumatic memory discourse is to be musealized and thus ultimately forgotten, it is the function of political memory art to counter such forgetting and to keep the pain of memory in the live conscience of the body politic.

<p style="text-align:center">*</p>

All of Salcedo's work is dedicated to this struggle against oblivion. Fragmentos came into being in the midst of Colombia's political campaign to put an end to decades of armed conflict,

Fig.23 Alfredo Jaar, *Geometry of Conscience*, 2010
Installation at the Museum of Memory and Human Rights,
Santiago de Chile

which by now has claimed over 250,000 lives. Here, too, the question of memory and aesthetics is most instantly tied to current national politics. When the government of President Juan Manuel Santos signed the UN-mediated peace treaty with the guerrillas, the FARC, in 2016, it was decided that three monuments would be built – one in Havana where the treaty was signed, one in New York at the United Nations, which had facilitated the negotiations, and one in Bogotá, capital of Colombia. Mariana Garcés, the minister of culture, asked Salcedo to design the Bogotá monument. The government's request did have a logic. Each of Salcedo's previous sculptures and installations, both in galleries and in public urban space, had been a counter-monumental memorial to the pain and suffering of all sides in the conflict. As one of Colombia's premier artists, she seemed predestined for the task. Reluctant to accept the culture minister's offer and skeptical of official government-sponsored monuments, Salcedo at first rejected the offer. Upon reflection, however, she quickly changed her mind, if only to prevent others building what she feared would be a traditional figurative and monumental eyesore.

Visitors enter the space walking up a narrow passage paved with bricks and lined by rough walls left from the ruins of the colonial building on either side. Through a raw door frame on the right, one catches a glimpse of an open outside space framed by residual walls of the original building, where a tree and a few large leafy plants grow beside the outside wall of the complex. On that wall, now seen from the inside, one can read the name Fragmentos in reverse. Moving on into the modern part of the building, one passes a white wall featuring a statement by the artist referring to the Peace Treaty and highlighting the fact that, for the first time, victims of sexual violence had been able to participate in the construction of a space commemorating the end of armed conflict.

The new construction, imaginatively embedded in the colonial ruin, consists of a minimalist modernist design supported by steel beams and featuring large glass walls, which permit views onto the residues of the colonial ruin outside,

weathered and crumbling walls surrounded by lush green bushes and vegetation. Throughout the building, visitors walk on a floor consisting of dark-grey unevenly sculpted tiles, made from 37 tons of melted weapons which the guerrillas had surrendered after signing the 2016 peace treaty. This spine of the rectangular building runs along a long hallway, with open inside rooms and outside spaces alternating to its right. The hallway leads slightly upwards, flowing into the largest room, a typically modernist white cube intended for art exhibits or large lectures and conferences. In this final room with its four white walls, the dark tiled floor assumes its most ominous and powerful effect. One suddenly realizes that it is this floor that conveys the ultimate meaning of Fragmentos: made from thousands of AK-47s returned to their material substance and shaped into an aesthetic statement, it is a monument to violence overcome and a promise of peace (fig.24). Throughout the inside of the building, this floor contrasts with the earthen grounds, green plants and ocher wall remnants of the colonial building outside the glass walls. Its dark-grey steel tiles extend from the spinal hallway into each of the three public spaces, dedicated to lectures, exhibits and video projections. The proximity of the sparse modernist architecture of glass, steel and white walls to the residual walls of the former colonial building, which is very much part of the total architectural plan, speaks volumes. The architectural past, though in a state of ruin, is preserved on this site dedicated to silent remembrance and commemorative art. It is as if the design of Fragmentos itself were to embody the very nature of memory: being of the past, but always and inevitably fragmentary and part of a present that remediates and preserves memory according to its own historical logic. Part sculptural installation, part memorial, part art museum, it is a space dedicated to the remembrance of a decades-long civil war in a society that still lacks an official politics of memory. It is intended to provide the ground for future art installations commemorating national suffering, for dialogues and discussions of art and politics in Colombia and elsewhere – and, as

Fig.24 Doris Salcedo, Fragmentos, 2018
1296 steel tiles, each 60 × 60 cm (23 ⅔ × 23 ⅔ in)
total 800 sq m (8611 sq ft)
Bogotá, Columbia

Salcedo hopes, for encounters of artists from the Global South who all too often lack their own institutions and public sites for exhibition and debate.

But the most extraordinary part of the project is the way in which this stunning floor with its unevenly shaped tiles, made of the steel from the guerrilla's weapons, was actually created. It involved politicians, the army and the police, guerrilla leaders and victims of sexual violence at a tenuous historical moment when peace and reconciliation seemed to be possible. There is no question that it is this floor on which visitors walk, this collectively created installation artwork, which is the conceptual and visual core of the space, foundation, as it were, for an alternative future. The story of how the melted steel of thousands of AK-47s came to be the sculpted floor of Fragmentos is essential to the memories it embodies.

Salcedo was confronted with a number of impossible tasks. Given the complexity of the peace negotiations, the FARC, mistrusting the Santos government's peace proposal, had agreed only to a truce, but had not surrendered their weapons. The UN had then facilitated the next stage of the process. They brought in large containers, placing them in FARC-dominated areas, and slowly but surely a majority of the guerrillas deposited their arms, which were then disabled by the UN and transported to a safe site. Though under nominal control of the UN, the containers still belonged to the FARC.

A first step was for Salcedo to approach the FARC to get them to agree to her plan to use the guerrillas' weapons. She started talking to Iván Márquez, the FARC leader who had negotiated the peace treaty. She presented her plan for the memorial, but he did not like it at all. He thought that people walking on a floor made of the steel from melted weapons was humiliating to the guerrillas. He also did not like Salcedo's focus on rape and sexual violence, which, as he well knew, had been quite common among the guerrillas themselves. When she convinced him that her project would focus on the perpetrators on all sides, he finally relented and accepted her design for the monument. The Santos government had fewer hesitations in

accepting the fact that the military, too, had committed sexual abuse in their war against the FARC.

Salcedo now had 37 tons of arms she needed to melt down in order to realize her project. The army was reluctant to help, sending her on a wild goose chase to various foundries across the country, though they knew they had the only facility powerful enough to do the job. Eventually the military were ordered by President Santos to cooperate. Salcedo now had control of the material for the process.

From the hundreds of survivors of sexual abuse she had interviewed, Salcedo picked 20 women, mainly from a group of women organizers called Mujeres Víctimas y Profesionales who had organized shelters for abused women across the country, teaching them how to deal with rape, how to survive, how to get compensation from the government, how to denounce what had happened to them. Salcedo had hoped to include 20 guerrilla women as well, but they were forbidden by their commanders to participate. It was this collective of 20 that ultimately gave uneven shape to the steel panels that formed the floor of Fragmentos. Since steel would have been too hard and too dangerous to hammer, Salcedo bought soft aluminum plates, which, after being hammered by the women into some non-shape, became the molds into which the molten steel was poured at the army's foundry to cast the final floor tiles (fig.25). The collective hammering and bonding, in which Salcedo herself participated, giving desired shape to the tiles, released the anger, the rage and ultimately the language with which the women gave public testimony about their experiences. As a witness of these women's traumatic memories, Salcedo was able to transform their haunting and symptomatically reenacted memories into a collective narrative in which the survivors speak publicly about their experience. This narrative is captured in a moving video documentary about the creation of Fragmentos. It is accessible online, and it is an essential part of the Fragmentos project itself.[4]

With the government, the military and the guerrillas all involved, perpetrators and victims on all sides have come

Fig.25 Doris Salcedo, *Fragmentos*, 2018
Documentary film, 25 mins 12 secs
Directed by Mayte Carrasco

together in the creation of Fragmentos. The project stands as proof of the peace process and as public reproach to the current government's policies. Its floor provides evidence against those who doubted that the FARC had ever surrendered their weapons. Fragmentos did receive major and mostly appreciative media coverage – as a work of art and counter-monument. Indeed, its effect on local visitors and its international resonance were significant.

At the same time, it now faces political headwinds. Like the Santiago museum, it was made possible by a sympathetic government eager to conclude the peace process and to acknowledge the past, but it is now facing obstruction by the conservative government in power since 2018. The fact that Iván Duque, President Santos's successor, shunned the official opening of Fragmentos in late 2018, was a sign of bad things to come. His electoral success was at least in part due to the fact that the peace treaty, meant to integrate the guerrillas into the body politic, was never fully accepted by the majority of the population. The work of a Colombian Truth and Reconciliation Commission, created only in 2018, has been undermined and sidelined by the new government, and other civil society agencies like the National Center for Historical Memory are currently being defunded. The armed conflict still divides the country, suspicions run high on either side and the Peace Treaty is up for grabs. As only a small fraction of its provisions has been implemented and violence continues in the countryside, some guerrilla groups have taken up arms again. And yet, memory debates about the armed conflict can no longer be simply repressed. Thus, in February 2020, President Duque laid down the first stone for a future National Historical Memory Museum in Bogotá, which, it is predicted, will create a false narrative primarily focused on the violence perpetrated by the guerrilla. Recoding the civil war as a problem of terrorism, the well-known and long-standing strategy of conservative Colombian governments, equals denial of the existence of murderous paramilitaries, denial of the military's involvement in extra-judicial killings, and denial of land

dispossessions, forced displacement and sexual violence on all sides of the armed conflict. In the meantime, Fragmentos, which is administratively part of the Museo Nacional de Bogotá, remains vulnerable to government intervention and reductions in state funding. But its role as counter-monument can only be enhanced by the state's project of building a National Memory Museum that advances a revisionist mirage of the conflict.

The Santiago museum faces problems of a different sort. Starting with the question of authority and control, Michelle Bachelet had anticipated future attacks on the museum from the nationalist right. She had wisely arranged for its independence from potentially shifting political winds by installing an administration responsible not to the government, but to a private foundation run by a board of 15 public figures from the worlds of academia and human rights. Thus, to this day, the museum has been protected from direct interference by recent conservative governments.

It soon became obvious how important that move was. Conservative attacks on the museum as a museum of shame nd hatred persisted from those quarters that kept defending the 1973 military coup as necessary to save the nation from inevitable ruin under Allende's Unidad Popular. The museum's agreement to limit its narrative to the 17 years of the dictatorship from 1973 to 1990 was the result of a necessary compromise between Bachelet and the conservative opposition. Agreement about the Allende years was simply not in the cards. This has placed the museum, at least temporarily, between a rock and a hard place. For the demand to teach about the Allende years was also articulated by the left, who found the exclusive focus on human rights violations inadequate to provide a politically full account of the recent past. Historical analysis, it was reasonably argued, required broader contextualization. The museum's focus on memory and testimony seemed to prevent such a debate about history.

In retrospect, however, the museum's strategy can be regarded as a ruse of history, for it postponed the political

accounting of the Allende years to some more propitious time in the future. The primary task was to assert the criminality of the regime against willed amnesia and apathy. The truth commissions had established beyond doubt that human rights had been massively violated. Their work went a long way to reestablish the dignity of the victims. On the other hand, this framing of the narrative deprived those victims of any recognition of their utopian political aims. Their political agency was thus written out of history. But, as in Argentina – where the dominant Holocaust slogan of 'Nunca más' had similarly depoliticized victimhood by relying on a notion of the passive and pure victim – this very move guaranteed that the discourse about the violation of rights and the criminality of the military regime would ultimately find broad recognition beyond the parameters of an ongoing political conflict concerning the socio-economic continuities of post-dictatorship Chile with the full-fledged economic neoliberalism of Pinochet's US-supported regime. Only the future will tell to what extent the Museum of Memory and Human Rights will be able to go beyond its current narrative and whether it will open up to other dimensions of national memory such as the Allende years or even the deep history of colonialism's effects on the Mapuche and other Indigenous peoples.

Both the Santiago museum and Fragmentos focus on individual suffering caused by political violence. Neither falls into the trap of victimology by focusing on individual victims only or by creating the absolute victim. Individual victims are highlighted in Santiago and forcefully implied in all of Salcedo's work via affective abstraction. However indirectly, both institutions raise questions of historical accountability and political responsibility in a long-term view including past, present and future. Clearly, the younger generation in Chile today demands an accounting of the Allende years and its social policies. But it is only through focus on the particular, always singular, case of victimization that an accumulation of loss for the whole of society can be made visible. Strategies of documentation vary in the two cases discussed in this chapter,

but both projects focus on the ultimate cost of political violence to society at large. Both the Santiago museum and Bogotá's counter-memorial depend on memory art to nurture national and transnational public debates by opening spaces for imagining alternative futures to bring about recognition and reconciliation.

Space/Time:
Guzmán, *Nostalgia de la luz*
and Kentridge,
The Refusal of Time

This book has juxtaposed works of memory art from parts of the Global South that challenge their viewers' affective and cognitive responses in different media. Installation is the open-ended form they have in common, whether they emerged from painting, sculpture, drawing, photography, video or animation. Some exude anger and frustration about the world's inability and unwillingness to remember, which is often exacerbated by denialist state policies. Others are closer to melancholy, which acknowledges, even embraces, the transitoriness of all things human. As installations drawing on complex aesthetic strategies derived from Western and non-Western traditions, they activate the spatial and temporal experience of the spectator. They all offer sensual insight into how different histories are imprinted on us and how memory and forgetting always intersect.
A broadly counter-monumental drive is shared by these works, much expanded beyond an earlier medium-specific notion of the counter-monument. At their deepest level, these works test our imaginative capacity for compassion, grief and empathy, confirming Nietzsche's conviction that 'only that which never stops hurting stays in memory.[1] If a living memory of others' suffering depends on sharing the pain, artworks have the ability to conjure up the pain of a secondary witnessing. Such mediated witnessing of violence and injustice is essential

to nurture public memory; it is always accompanied by a cognitive dimension, the reflection induced by the challenges that the artwork mobilizes through its aesthetic strategies. The sensual beauty of the work, combined with the often shocking embodiment of what it represents, enhances the empathy and the knowledge it generates. The mix of affect and cognition varies from artist to artist as well as from viewer to viewer. Some works will get closer than others to reproducing the sense of traumatic experience itself. It is in the aesthetic experience of these artworks that memory is created. Whether focused more on empathy or on cognition, they all articulate strong ethical demands on their societies and they speak to an emerging global sphere of commemorating human-caused disasters across nations and across continents. They are acts of memory in the present. At the same time, they embody a differential globality in the ways they address local histories and weave local aesthetic traditions into a transnational fabric made up of multi-directional aesthetic and political threads. Just as there is not one modernism or one single modernity, there is no one single Global South.

If memory comes inevitably with pain and grief, the lure of forgetting is easy to give in to. This is all the more likely in a consumer society predicated on a short-term present and its data-based regime of the timeless algorithm. Alexander Kluge once spoke of the attack of the present on the rest of time. He called writers 'the guardians of the last residue of grammar, the grammar of time, i.e., the difference between present, future, and past, guardians of difference'.[2] The visual artists treated in this book stand in solidarity with Kluge's writers as guardians of time and difference. Their works cast light on that limited and fragile redemptive power that art offers, as it fends off despair or the disabling melancholy arising from history's catastrophes.

To me, two visual essays best embody the redemptive dimension that art can offer even as it confronts the brutality of history: Patricio Guzmán's *Nostalgia de la Luz* (*Nostalgia for the Light*) (2010), a documentary cinematic reflection on the Chilean

military dictatorship, and William Kentridge's *The Refusal of Time* (2012), an immersive multimedia black box installation, which deals critically and satirically with colonial history in its relation to the modern regime of time and space. Their visual essays do not make the pain of memory disappear, but they frame it in an expanded context. Stunning images support two very different narratives, one more on the side of loss and melancholy, the other on the side of active resistance. Both works treat time/space at the self-reflexively largest scale possible in terms of the cosmic origins of life and the relativity of time and space. Guzmán counterposes the gaze into the beauty of the night sky from the powerful observatories in the Atacama Desert with the gaze of women survivors who search the desert ground for remnants of Chilean *desaparecidos*. In his filmic exploration of the starry sky and the pre-historical rock carvings in the Atacama, accompanied by his quiet but intense voice-over, Guzmán stresses the affinity between astronomy and archaeology, depth of space as inseparable from the depth of time. He notes that the starlight we see in the night sky comes to us from a deep past, light years away. In his lecture *Refuse the Hour*, distinct from but related to *Refusal of Time*, Kentridge playfully reverses this thought and suggests that every happening once visible on earth must still be visible in outer space, our deepest past light years away from our galaxy.[3] In cosmic perspective, nothing of history is ever lost, even if it is no longer accessible to the human eye. In their focus on the cosmic scale of time and space, these two works come full circle from the intimate scale of the bed, the chair and the domestic habitat at the start of this book.

As Einstein once suggested, artistic and scientific experience have in common that they permit us to extract ourselves from the hurt and tumult of everyday life.[4] If the gaze into the infinity of the cosmos or an aesthetic experience may reconcile the viewer to the tenuousness and pain of the human condition, it clearly does not mitigate the pain of the Chilean women searching for their dead near the site of a major detention camp of the military dictatorship. One of them in Guzmán's film

pointedly laments that the telescopes on the mountain cannot be turned downward to reveal what is in the ground. The pain of these women, little shovels in hand searching the desert ground for bones of their loved ones, reminds us that there can never be total redemption. Despair, however, is held at bay by the resilience of these women, their will to know, their refusal to give up the search.

Refusal and its many dimensions is the main theme of *The Refusal of Time*, Kentridge's visual essay on time and space. Instead of a narrative held together by the voice of the narrator-filmmaker, Kentridge offers us a filmic montage of rather chaotic public and private scenes unspooling on the walls of the black box. Developed together with Peter Galison, historian of science, Kentridge's exuberantly operatic installation explores the imposition of a worldwide regime of time zones in the late 19th century, centered in Greenwich, in the heart of the British Empire. The rational and mechanical control of time was coupled at the 1884 Berlin West Africa conference with the cartographic establishment of artificial borders on the African continent, drawn with a ruler and oblivious to historical structures of lived geographies. Not coincidentally, the simultaneous control of time and the control of colonial space were historically contingent and inherently linked to each other.

However, *The Refusal of Time* does not give us a lesson in physics or history. The establishment of the Greenwich meridian is visualized in a kind of grotesque history play evolving on five screens and moving along from left to right on three walls of the black box. The image sequences of *The Refusal of Time* begin with a ticking metronome, with others soon emerging and increasingly losing their beat, some speeding up, others slowing down as the film is variously sped up or slowed down. The effect, at any rate, is a loud chaos of tick-tocks at different speeds. The measurement of time is out of joint.

In another sequence, the anarchist bombing of the Royal Observatory in Greenwich of 1894 is transposed to Dakar in 1916. The revolt against Greenwich time is coded as an anti-colonial refusal of an imposed regime of time, its slogan:

GIVE US BACK OUR SUN. Clock time henceforth was opposed to lived time, as we know from Bergson, Proust and the time experiments of modernist narrative. In *The Refusal*, it is the time of the body, time of breathing in and breathing out, that opposes the tick-tock of the metronome. It is film itself as a medium, however, that makes the relativity of time visible. The cinema as time machine was invented in those same decades. When film is run backwards, it stages the illusion of the reversibility of time, a phenomenon Kentridge uses amply in the vignettes of *The Refusal*. This instability of time of course relates fundamentally to memory. In its emphasis on asynchrony and the multiplicity of volatile temporalities across the world, *The Refusal of Time* rejects any idea of some unified global time separate from historically differentiated lived times and their memory constellations. To refuse clock time is an act of resistance not only in a colonial context; it is resistance to the time of an overwhelming present and its demands, resistance to the second nature of social norms, and ultimately a critical negotiation of transitoriness and mortality itself. Not to escape it, but to embrace it, to create a working relationship with the past, acknowledging the inevitable *memento mori* and practicing it by remembrance of the dead. This is what memory art does.

The highpoint of *The Refusal* takes the form of yet another shadow procession – this time, however, it is the black silhou-ettes of live actors that make up an exhilarating procession emerging on the first screen on the left and marching around to the screen on the right wall. As in the film *Procession* of 1999, they carry objects of everyday life with them. Several musicians leading the procession play an anarchic, rhythmic tune on wind instruments – tuba, trumpet, trombone – accompanied by drumming as they march in the procession. Rhythm and sound come alive thanks to human breath, which can never be subjected to a strict metrical regime. This shadow procession does not end in surreal anarchy like the shadow procession of 1999 (see Chapter 4), but culminates in a robust celebration of African life emerging from oppression and colonialism.

Together with the exuberant dance by Dada Masilo, dressed in flying white gowns, and presented in reverse cinematic motion as falling black shards are seen rising around the dancer, this procession gives a sense of uplift necessary to face the relentless focus of memory art on trauma, violence and injustice, which threaten to pull history and memory into a black hole of oblivion.

Memory art labors against such oblivion and the resulting amnesia. By refusing to treat the past as simply past, it practises its own refusal of time. It is driven by the desire for an alternative future embedded in remembrance. It thereby affirms its solidarity with the complex interweaving of temporalities at stake in memory. By appropriating and transforming artistic strategies of Western modernism and postmodernism, the memory art from the Global South strikes me as avant-gardist in its self-conscious coupling of aesthetics with the politics of memory. But it is an avant-gardism quite different from that of the historical avant-garde. Avant-gardism not as a model of progress or utopia dependent on estrangement (Brecht) and shock experience (Benjamin) or on the most advanced, cutting-edge state of the artistic material (Adorno) or, for that matter, on the disavowal of figurative realisms as in the post-1945 neo-avant-garde; avant-gardism instead as a challenge to think politically through spectacular sensuous installations that create affect and cognition both on the local and the global stage. Avant-gardism not as programmatic destruction of traditional notions of autonomy and the work, but as their transformation, which insists on the *Eigensinn*, the differential specificity of aesthetic work.[5] The forms of memory art discussed in this book re-inscribe and mark a boundary between artistic practice and all that is part of a presentist culture of quick consumption and careless forgetting. In all of these works, the remembrance of historical trauma is aesthetically mediated with contemporary politics in such a way that deep structures of domination and social conflict in our world are illuminated and become graspable for the thoughtful spectator anywhere who is, if not transformed, at least deeply affected

by the experience of the work. The national and transnational success of the artists treated in this book bears this out. In this sense, their work is political through and through. The use of traditional, even obsolete, techniques of representation marks a turn against a technological triumphalism that privileges only the digital. It is no longer a philosophy of history that anchors this kind of avant-gardism, but on the contrary, a sustained doubt in merely technological progress combined with a political critique of a failing present that has not redeemed the promises of modernity. This avant-gardism from the Global South offers an intriguing paradox: it implodes the distinction between tradition and the avant-garde since it transforms the critique of modernity, which was always already part of European avant-gardism itself, for an unsettled decolonizing world.

Afterword

This book has taken shape over several decades. A life-long focus on German memory politics and its literary and visual manifestations led to my interest in artists in the Global South who confronted state violence, apartheid and civil war in their societies. My work on the political struggles to remember the Holocaust and the Third Reich enabled cross-cultural connections and friendships that thrived in many conversations and meetings over the years. Slowly I gained a measure of confidence and courage to write about these artists, despite the fact that their work is quite distant from my primary expertise. When I noticed that publications on their work were mainly monographic, I decided to put them in dialogue with each other across national and continental borders. The South-to-South axis that organizes my chapters is thus constantly crossed by North-to-South and South-to-North relationships through my use of critical theory and the artists' own critical appropriation of Northern artistic trends from a postcolonial perspective.

The concern with memory and its repression or evasion of violence, trauma and suffering raises major questions about how time is experienced, perceived and lived in global modernity. It was the Western museum boom of the 1990s that first made me aware of a subtle, but fundamental, change in the relations between present, past and future. It was not just a shift of focus from the future to the past, from anticipation to memory, which found its political correlate in the upsurge of the global human rights movement. It was rather the puzzling interpenetration of pasts, presents and futures across the globe that needed to be thought through. A new threat emerged from digital culture's rule of the algorithm and its constitutive neglect of the temporality essential to human life. It is not

simply the threat which forgetting has always posed to memory's life-sustaining power. The threat is now exacerbated by amnesia about temporality itself as the internet sucks up all dimensions of time into the mirage of a flat and timeless present. Consciously or not, any memory art worth its salt tries to counteract this insidious trend. Despite their often problematic history, museums are charged with playing a novel role along with memory art in the negotiation and guardianship of human time.

The comparative dimension of my approach emerged in an earlier short book on shadow play in the work of Nalini Malani and William Kentridge. It expanded to other modes of memory art, such as Guillermo Kuitca's or Vivan Sundaram's, as I learned from critics and art theorists like Geeta Kapur, Graciela Speranza, Nelly Richard and Saloni Mathur about the local dimensions of these artists' aesthetic and political projects. Throughout, the intensely powerful work of Doris Salcedo has remained a guiding star in my thinking about how to come to terms with an ethics of vision and a politics of remembrance rendered in aesthetically persuasive and politically challenging forms.

Writing in the time of the pandemic, my main regret is that I could not include a few artists whose work I did not yet know well enough to write about without long-distance travel and time abroad. But I trust that the comparative juxtapositions limited to just a few artists in this book can be supplemented and critically expanded by others in the future. In that sense, I consider this book as a suggestion for further critical thinking.

Any work of such long gestation owes more debts than can be acknowledged, but major thanks go to the artists whose works are discussed in this book. As a Europeanist by training, I could not have written it without their substantial help in frequent meetings, conversations and email exchanges. Thanks are also due to friends and colleagues who have read and advised on chapter drafts: Marianne Hirsch, who has read the whole manuscript with a critical eye and with whom I have been co-directing a University Seminar on Cultural Memory

at Columbia for many years; anthropologist Roz Morris, close colleague and co-teacher at the Institute for Comparative Literature and Society, whose work with and on Kentridge has been pathbreaking; philosopher and art theorist Juliane Rebentisch, whose work on installation art in the Critical Theory tradition has strongly influenced my thinking. Their comments proved invaluable for revisions and expansions of the argument.

In addition, I am indebted to all those institutions that invited me to lecture on the subject of this book in recent years: the Museu de Arte do Río in Río de Janeiro, the Museo de la Memoria y Derechos Humanos in Santiago de Chile, the Museo Nacional de Colombia (Fragmentos) in Bogotá, the European Commission for its EUROM conference in Barcelona, the Centre Georges Pompidou in Paris, the Tate Modern in London, the Irish Museum of Modern Art in Dublin, the Mosse Lectures in Berlin, the Literaturhaus in Munich, and the Mnemonics Summer School and the Institute for Social Research in Frankfurt.

Special thanks to Marcus Verhagen and Lucy Myers, who approached me out of the blue in late 2018 with a query: would I be interested in writing a short book on memory art to be published in this new series on contemporary art? I agreed with pleasure, as the idea of a short book aimed at students and the general reader seemed just right at a time when long scholarly books have become prohibitively expensive and seem destined mainly for library shelves rather than circulation. Thanks also to Rochelle Roberts who helped secure images and Michela Parkin for careful and competent line editing. The limited number of black and white images in this book is easily remedied. Indeed, all of the works discussed here are accessible in color on the internet. A brief bibliography at the end gives some suggestions for further readings.

Finally, I thank my wife Nina Bernstein, who has always been my best editor in every sense of the word.

Notes

FOREWORD

1 Theodor Adorno, 'The Meaning of Working Through the Past', in *Critical Models; Interventions and Catchwords*, translated by Henry W. Pickford (New York: Columbia University Press, 2005), p.91.
2 Svetlana Boym, *The Future of Nostalgia* (New York: Basic Books, 2001).

INTRODUCTION

1 On the shifting sense of temporality in Europe and the United States in the 1990s, see Andreas Huyssen, 'Time and Cultural Memory at Our Fin de Siècle', in *Twilight Memories: Marking Time in a Culture of Amnesia* (New York and London: Routledge, 1995), pp 1–9. On the broader dimen-sions of the 'memory boom', see Andreas Huyssen, 'Present Pasts: Media, Politics, Amnesia', in *Present Pasts: Urban Palimpsests and the Politics of Memory* (Stanford, CA: Stanford University Press, 2003), pp 11–29.
2 For an excellent related study with a focus on trauma, see Jill Bennett, *Emphatic Vision: Affect, Trauma, and Contemporary Art* (Stanford, CA: Stanford University Press, 2005).
3 See Michael Rothberg, *Multidirectional Memory: Remembering the Holocaust in the Age of Decolonization* (Stanford, CA: Stanford University Press, 2009).
4 On the current state of transcultural memory studies in the arts and beyond, see Ayşe Gül Altinay, Maria José Contreras, Marianne Hirsch, Jean Howard, Banu Karaca, Alisa Solomon, eds, *Women Mobilizing Memory* (New York: Columbia University Press, 2019).
5 See the superb monographs on Nalini Malani and Doris Salcedo by Mieke Bal; Leora Maltz-Leca's *William Kentridge: Process as Metaphor and Other Doubtful Enterprises* (Oakland: University of California Press, 2018); Saloni Mathur's book on Vivan Sundaram and Geeta Kapur's *A Fragile Inheritance: Radical Stakes in Contemporary Indian Art* (Durham, NC and London: Duke University Press, 2019); and Raphael Rubinstein, *Guillermo Kuitca* (London: Lund Humphries, 2020).
6 Global South here is not meant in the strict geographic sense. It rather refers to a history and a condition of entanglement with the North under the rubric of globalization. On the history of the term, see Arif Dirlik, 'Global South: Predicament and Promise', *The Global South*, vol.1, no.1 (2007), pp 12–23.

7 For this more traditional art activism, see Oliver Marchart, *Conflictual Aesthetics: Artistic Activism and the Public Sphere* (Berlin: Sternberg Press, 2019).

8 See also Mieke Bal, Jonathan Crewe and Leo Spitzer, eds, *Acts of Memory: Cultural Recall in the Present* (Hanover and London: University Press of New England, 1999).

9 On the earlier debate about unrepresentability, see Saul Friedlander, ed., *Probing the Limits of Representation: Nazism and the 'Final Solution'* (Cambridge, MA: Harvard University Press, 1992).

10 On the recent erection of walls and borders as a reaction formation to globalization, see Wendy Brown, *Walled States, Waning Sovereignty* (New York: Zone Books, 2010).

11 Theodor W. Adorno, *Aesthetic Theory*, translated by Robert Hullot Kentor (Minneapolis: University of Minnesota Press, 1997), p.5.

12 ibid., p.6.

13 ibid., p.4.

14 Juliane Rebentisch, *Aesthetics of Installation Art* (Berlin: Sternberg Press, 2012) and *Theorien der Gegenwartskunst* (Hamburg: Junius Verlag, 2013). On aesthetic experience, see Rüdiger Bubner, *Ästhetische Erfahrung* (Frankfurt am Main: Suhrkamp, 1989). I would note that Bubner's approach is fundamentally different from Nicolas Bourriaud's *Relational Aesthetics* (Dijon: Les Presses du réel, 2002). For a critique of Bourriaud, which Rebentisch shares, see Claire Bishop, 'Antagonism and Relational Aesthetics', *October*, vol.110 (2004), pp 51-79.

15 Theodor W. Adorno, 'Art and the Arts', translated by Rodney Livingstone, in *Can One Live After Auschwitz? A Philosophical Reader*, Rolf Tiedemann, ed., (Stanford, CA: Stanford University Press, 2003), pp 368-87.

16 Theodor W. Adorno, *Philosophy of New Music*, translated by Anne G. Mitchell and Wesley V. Blomster (New York: Continuum, 1985), p.30.

17 Adorno, *Aesthetic Theory*, pp 261, 177. See Peter Gordon, 'Social Suffering and the Autonomy of Art', *New German Critique*, vol.143 (August 2021), pp 125-46 (special issue on Adorno's *Aesthetic Theory* at Fifty).

18 Peter Osborne – beside Rebentisch another influential critic who rethinks Adorno in relation to contemporary post-conceptual art – is right to criticize memory art practices, which bank on simplistic notions of authenticity and identity of the witness. He is also right to point to the increasing commodification of the art world via big money, mega-events and ever more biennales, which create the illusion of a seamless globality. But his tendency to simply oppose memory to history, to relegate 'art as memory' to its national dimension and, by contrast, to validate transnational post-conceptual art as anti-aesthetic and thus not prone to the culture industry's commodification, is strangely undialectical. While he himself discusses some examples of complex memory art (not by coincidence taken from the context of the Global South), his theoretical approach does not sufficiently acknowledge how the critical memory art of the Global South undercuts such oppositions and opens up new possibilities for spectators to engage with such critical art practices. Missing from Osborne's rethinking of Adorno is a thick notion of aesthetic experience, as Juliane Rebentisch has persuasively argued in *Theorien*,

pp 193–9. See Peter Osborne, *Anywhere Or Not At All: Philosophy of Contemporary Art* (London: Verso, 2013). For a more complex reading of transnational mega-events in the arts, see Okwui Enwezor, 'Mega-Exhibitions: The Antinomies of a Transnational Global Form', in Andreas Huyssen, ed., *Other Cities, Other Worlds: Urban Imaginaries in a Globalizing World* (Durham, NC and London: Duke University Press, 2008), pp 147–78.

19 The notion of the counter-monument was first developed by James E. Young, *The Texture of Memory* (New Haven, CT, and London: Yale University Press, 1993), pp 27–48, with specific reference to Holocaust monuments in Germany.

20 The discussion at the CCCB: Centre de Cultura Contemporània de Barcelona can be accessed at https://www.cccb.org/en/multimedia/videos/william-kentridge-and-nalini-malani/234532; the discussion organized by the Kiran Nadar Museum of Art in New Delhi as part of #KNMATalks, with Carolyn Christov Bakargiev, Director – Castello di Rivoli Museo d'Arte Contemporanea, in conversation with artists William Kentridge and Nalini Malani, in a talk inspired by Andreas Huyssen's book *The Shadow Play as Medium of Memory* (Milano: Charta, 2013), #KNMAIndia #ContemporaryArt #ArtPractises #KNMATalks #ShadowPlay, is accessible at https://www.youtube.com/watch?v=rXxG-Q8tEw0.

21 On this dialectic of *Deckerinnerung* in the case of Argentinian memory politics, see Andreas Huyssen, 'Resistance to Memory: The Uses and Abuses of Public Forgetting', in Max Pensky, ed., *Globalizing Critical Theory* (New York: Rowman and Littlefield, 2005), pp 165–84.

22 See Amy Sodaro, *Exhibiting Atrocity: Memorial Museums and the Politics of Past Violence* (New Brunswick, NJ: Rutgers University Press, 2018).

CHAPTER 1

1 See my earlier catalogue essay 'Guillermo Kuitca: Painter of Space', in *Guillermo Kuitca: Everything. Paintings and Works on Paper, 1980–2008* (London: Scala Publishers, 2009), pp 22–33.

2 Email to the author, 13 October 2019.

3 Graciela Speranza, *Guillermo Kuitca: Obras 1982–1998. Conversaciones con Graciela Speranza* (Buenos Aires: Grupo Editorial Norma, 1998), p.65, author's translation.

4 ibid., p.26.

5 ibid.

6 Karen Wright, 'Mapping Kuitca', in *Guillermo Kuitca: Theatre Collages* (London: Hauser & Wirth, 2005), n.p.

7 Adrian Dannat, 'Opera Works', *The Art Newspaper*, no.131 (December 2002), p.28.

8 'Conversation with Carlos Basualdo', in Nancy Princenthal, Carlos Basualdo, Andreas Huyssen, *Doris Salcedo* (London: Phaidon Press, 2000), p.17.

9 Mieke Bal, 'The Politics of Anthropomorphism', in *of what one cannot speak: Doris Salcedo's political art* (Chicago and London: University of Chicago Press, 2010), pp 75–120.
10 Cf. Andreas Huyssen, 'Unland: The Orphan's Tunic', in Princenthal, Basualdo, Huyssen, *Doris Salcedo*, pp 90–103.
11 Charles Merewether, 'An Interview with Doris Salcedo', in *Unland: Doris Salcedo* (New York, San Francisco: Museum of Modern Art, 1999), n.p.
12 Interview with the author, 29 February 2020.

CHAPTER 2

1 Cf. my earlier catalogue essay, 'The Memory Works of Vivan Sundaram', in Haus der Kunst, ed., *Vivan Sundaram: Disjunctures* (Munich: Prestel, 2018).
2 Geeta Kapur, 'Memorial', in *After the Event: New Perspectives on Art History*, Charles Merewether and John Potts, eds (Manchester: Manchester University Press, 2010), p.134.
3 Cf. Jill Bennett, *Emphatic Vision: Affect, Trauma, and Contemporary Art* (Stanford: Stanford University Press, 2005), p.10.
4 'Conversation with Carlos Basualdo', in Nancy Princenthal, Carlos Basualdo, Andreas Huyssen, *Doris Salcedo* (London: Phaidon Press, 2000), p.12.
5 ibid.
6 ibid., p.137.
7 ibid., p.140.
8 Luis Buñuel, *My Last Sigh* (New York: Vintage Books, 1984). Quote found online, http://www.cocosse-journal.org/2014/06/luis-bunuel-life -without-memory-is-no.html. Accessed 4 January 2022.

CHAPTER 3

1 See also Mieke Bal, 'Acts of Memory', in *of what one cannot speak: Doris Salcedo's political art* (Chicago: University of Chicago Press, 2010), pp 191–242.
2 See Andreas Huyssen, '*Palimpsesto*: Writing in Water and in Light', White Cube catalogue for Doris Salcedo show (Aosta, Italy: Musumeci, 2018), pp 4–11.
3 See http://magazine.art21.org/2015/09/08/kentridge-kapoor-chelsea -manning/. Accessed 15 August 2021.
4 William Kentridge, *Triumphs and Laments* (Cologne: Verlag der Buchhandlung Walther König, 2018), p.54. On the collaborative nature of the project, see Pamela Allara, 'William Kentridge's *Triumphs and Laments*: The Challenges and Pleasures of Collaboration', *de arte*, vol.54, no.1 (2019), pp 60–85.

CHAPTER 4

1 For an earlier version of this argument, see Andreas Huyssen, *William Kentridge and Nalini Malani: The Shadowplay as Medium of Memory* (Milan: Charta, 2013).

2 On the influence of the South African tradition of expressivist charcoal drawings by Mslaba Dumile Geelboi Mgxaji Feni, the 'Goya of the Townships', for Kentridge, see Kate McCrickard, *William Kentridge* (London: Tate Publishing, 2012), p.7. On the use of Kalighat painting, see Johan Pijnappel's interview with Malani in *Nalini Malani* (Milan: Edizioni Charta, 2007), pp 39–42.

3 Johan Pijnappel, 'The missing Link: Nalini Malani's Experimental Films from 1969–1976', in Sophic Duplaix, ed., *Nalini Malani: The Rebellion of the Dead*, Centre national d'art et de culture George Pompidou, Paris (Berlin, Hatje Cantz Verlag, 2017), pp 80–111.

4 Johan Pijnappel, 'Selected Biography: Compulsions toward a Filmic View', in Zasha Colah, ed., *Nalini Malani: In Search of Vanished Blood*, dOCUMENTA (13), Kassel (Hatje Cantz Verlag, Ostfildern, 2012), pp 60–87.

5 Heiner Müller, *Despoiled Shore Medea-material Landscape with Argonauts*, Dennis Redmond (trans.), 2002, https://mullersmedea.files.wordpress .com/2011/12/despoiled.pdf. Accessed 14 March 2022.

6 Daniel Kuraković and Linda Jensen, 'Quarries of Blindness and Shadows of Hope: A Conversation with Nalini Malani', *Torrent* (Summer 2012), pp 6–28.

7 Nalini Malani, *Stories Retold* (New York: Bose Pacia, 2004), p.1.

8 For the constitutive link between artistic process and the political procession in Kentridge's work, see Leora Maltz-Leca, *William Kentridge: Process as Metaphor and Other Doubtful Enterprises* (Oakland: University of California Press, 2018), esp. Chapter 3. Maltz-Leca reads Kentridge's work as fundamentally invested in the postcolony, i.e., in South African contemporaneity and its politics of memory and forgetting.

9 On the close relationship of drawing to writing in Kentridge, see Rosalind Morris, 'Drawing the Line at a Tree-Search: The New Landscapes of William Kentridge', in Rosalind Krauss, ed., *William Kentridge: October Files 21* (Cambridge, MA and London: MIT Press, 2017), pp 113–46.

10 Cited in Maltz-Leca, *William Kentridge*, p.261.

11 Mark Rosenthal, ed., *William Kentridge: Five Themes* (New Haven, CT and London: Yale University Press, 2009), p.67.

12 For a detailed discussion of *Mine*, see Rosalind Krauss's essay '"The Rock": William Kentridge's Drawings for Projection', *October*, vol.92 (2000), pp 3–35. My understanding of Kentridge's work owes a great deal to this pathbreaking essay, which, different from my and Maltz-Leca's approach, incorporates Kentridge into a formalist history of Western modernism and its focus on the medium.

13 William Kentridge, 'Felix in Exile: Geography of Memory', in Carolyn Christov-Bakargiev, *William Kentridge* (Brussels: Société des Expositions du Palais des Beaux Arts de Bruxelles, 1998), p.96.

14 See William Kentridge, 'Ubu and the Procession', in Mark Rosenthal, ed., *William Kentridge: Five Themes*, San Francisco Museum of Modern Art in association with Yale University Press (New Haven, CT: Yale University Press, 2009), p.131.

15 ibid.

16 For a more detailed analysis of the three parts, see Andreas Huyssen, *William Kentridge, Nalini Malani: The Shadow Play as Medium of Memory* (Milano: Charta, 2013), pp 25–9.

17 Cited in Carolyn Christov-Bakargiev, *William Kentridge* (Brussels: Société des Expositions du Palais des Beaux Arts de Bruxelles, 1998), p.156. This same material was also part of Kentridge's Norton Lectures at Harvard in 2012.

18 ibid., p.157.

19 First Norton Lecture, 'Drawing Lesson 1: In Praise of Shadows', in *Six Drawing Lessons* (Cambridge, MA and London: Harvard University Press, 2014).

CHAPTER 5

1 Michael Rothberg, *Multidirectional Memory* (Stanford: Stanford University Press, 2009). See also Marianne Hirsch, *The Generation of Postmemory* (New York: Columbia University Press, 2012).

2 See Andreas Huyssen, 'Memory Culture and Human Rights: A New Constellation', in Klaus Neumann and Janna Thompson, eds., *Historical Justice and Memory* (Madison, WI: University of Wisconsin Press, 2015), pp 27–44.

3 On Holocaust effects, see Ernst van Alphen, *Caught by History: Holocaust Effects in Contemporary Art, Literature, and Theory* (Stanford: Stanford University Press, 1998).

4 Chaitanya Sambrani, 'Tracking Trash: Vivan Sundaram and the Turbulent Core of Modernity', in Vivan Sundaram, *Trash* (Mumbai: Chemould Prescott Road, 2008), pp 7–9.

5 On the motif of Baudelaire's rag picker in Sundaram's work, see Deepak Ananth, 'Seams', in Vivan Sundaram, *Gagawaka: Making Strange* (Mumbai: Chemould Prescott Road, 2012), pp 10–27.

6 ibid., p.11.

7 Saloni Mathur, *A Fragile Inheritance: Radical Stakes in Contemporary Indian Art* (Durham, NC, and London: Duke University Press, 2019), p.148.

CHAPTER 6

1 For a reading of *Palimpsesto*, see Andreas Huyssen, '*Palimpsesto*: Writing in Water and in Light', White Cube catalogue for Doris Salcedo exhibition (Aosta, Italy: Musumeci, 2018), pp 4–11.

2 Quoted in Dalya Alberge, 'Welcome to Tate Modern's floor show –

it's 548 foot long and is called Shibboleth', *The Times*, 9 October 2007, https://www.thetimes.co.uk/article/welcome-to-tate-moderns-floor -show-its-167m-long-and-is-called-shibboleth-mwktzwgwbdb. Accessed 12 January 2008.

3 Giles Tillotson, 'A Visible Monument: Architectural Policies and the Victoria Memorial Hall', in Philippa Vaughn, ed., *The Victoria Memorial Hall, Calcutta: Conceptions, Collections, Conservation* (Mumbai: Marg Publications, 1997), p.8.

4 Geeta Kapur, *When Was Modernism: Essays on Contemporary Cultural Practice in India* (New Delhi: Tulika, 2007). On *History Project*, see her 'Monument as Bricolage', in Vivan Sundaram, *History Project* (New Delhi: Tulika Books, 2017), pp 55–120.

5 Arindam Dutta, 'Staging Absence', in Sundaram, *History Project*, p.187.

CHAPTER 7

1 On the fraught relationship between the culture of memory and human rights, see Andreas Huyssen, 'Memory Culture and Human Rights: A New Constellation', in Klaus Neumann and Janna Thompson, eds., *Historical Justice and Memory* (Madison, WI: University of Wisconsin Press, 2015), pp 27–44.

2 For a superb study of political memory in Chile, see Nelly Richard, *Eruptions of Memory* (Cambridge: Polity Press, 2019); and Steve J. Stern, *Reckoning with Pinochet: The Memory Question in Democratic Chile, 1989–2006* (Durham, NC and London: Duke University Press, 2010).

3 For an account of the museum's project, see Ricardo Brodsky, *Trampas de la Memoria* (Santiago de Chile: FLASCO-Chile, 2018); and Amy Sodaro, *Exhibiting Atrocity: Memorial Museums and the Politics of Past Violence* (New Brunswick, NJ: Rutgers University Press, 2018).

6 https://www.youtube.com/watch?v=d7rAb2O0JV8. Accessed 15 August 2021.

CODA

1 Friedrich Nietzsche, *Genealogy of Morals*, translated by Horace B. Samuel (New York: Macmillan, 1924), p.66.

2 Alexander Kluge, 'Die Differenz: Heinrich von Kleist', in *Theodor Fontane, Heinrich von Kleist, Anna Wilde* (Berlin: Wagenbach, 1987), p.80, author's translation.

3 William Kentridge, 'Refuse the Hour', in *The Refusal of Time* (Paris: Éditions Xavier Barral, 2012).

4 Albert Einstein, 'The Common Element in Artistic and Scientific Experience', in M. Janssen et al., eds, *The Collected Papers of Albert Einstein*, vol.7 (Princeton: Princeton University Press, 2002), pp 379–81.

5 The notion of *Eigensinn* was elaborated in its broadest sense by Alexander Kluge and Oskar Negt in Devin Fore, ed., translated by Richard Langston *History and Obstinacy* (New York: Zone Books, 2014).

Further reading

Adorno, Theodor W., *Aesthetic Theory*, translated by Robert Hullot Kentor (Minneapolis: University of Minnesota Press, 1997)

Bal, Mieke, *of what one cannot speak: doris salcedo's political art* (Chicago and London: University of Chicago Press, 2010)

Bal, Mieke, *In Medias Res: Inside Nalini Malani's Shadow Plays* (Ostfildern: Hatje Cantz, 2016)

Bennett, Jill, *Emphatic Vision: Affect, Trauma, and Contemporary Art* (Stanford, CA: Stanford University Press, 2005)

Friedlander, Saul, ed., *Probing the Limits of Representation: Nazism and the 'Final Solution'* (Cambridge, MA: Harvard University Press, 1992)

Hirsch, Marianne, *The Generation of Postmemory: Writing and Visual Culture After the Holocaust* (New York: Columbia University Press, 2012)

Huyssen, Andreas, *Twilight Memories: Marking Time in a Culture of Amnesia* (New York and London: Routledge, 1995)

Huyssen, Andreas, 'Unland: The Orphan's Tunic', in Nancy Princenthal, Carlos Basualdo, Andreas Huyssen, *Doris Salcedo* (London: Phaidon Press, 2000), pp 90–103

Huyssen, Andreas, *Present Pasts: Urban Palimpsests and the Politics of Memory* (Stanford, CA: Stanford University Press, 2003)

Huyssen, Andreas, 'Guillermo Kuitca: Painter of Space', in *Guillermo Kuitca: Everything. Paintings and Works on Paper, 1980–2008* (London: Scala Publishers, 2009), pp 22–33

Huyssen, Andreas, 'Shadows and Memories: Nalini Malani', in Musée cantonal des Beaux Arts, ed., *Nalini Malani: Splitting the Other (Retrospective 1992–2009)* (Lausanne: Hatje Cantz, 2010), pp 42–9

Huyssen, Andreas, *William Kentridge and Nalini Malani: The Shadowplay as Medium of Memory* (Milan: Charta, 2013)

Huyssen, Andreas, "Vivan Sundaram's Fashion Show as Postmortem," in Saloni Mathur and Miwon Kwon, eds, *Making Strange: Gagawaka and Postmortem by Vivan Sundaram* (Los Angeles: Fowler Museum at UCLA, 2015), pp 65–81

Huyssen, Andreas, 'The Memory Works of Vivan Sundaram', in Haus der Kunst ed., *Vivan Sundaram, Disjunctures* (Munich: Prestel, 2018), pp 88–101

Huyssen, Andreas, 'Fragmentos: Interview with Doris Salcedo', in Nicolaus Schafhausen/Mirjam Zadoff, eds. *Tell me about yesterday tomorrow* (Munich: NS-Dokumentationszentrum, 2021), pp 92–106

Kapur, Geeta, *When Was Modernism: Essays on Contemporary Cultural Practice in India* (New Delhi: Tulika, 2007)

Krauss, Rosalind ed., *William Kentridge: October Files 21* (Cambridge, MA and London: MIT Press, 2017)

Maltz-Leca, Leora, *William Kentridge: Process as Metaphor and Other Doubtful Enterprises* (Oakland: University of California Press, 2018)

Marchart, Oliver, *Conflictual Aesthetics: Artistic Activism and the Public Sphere* (Berlin: Sternberg Press, 2019)

Mathur, Saloni, *A Fragile Inheritance: Radical Stakes in Contemporary Indian Art* (Durham, NC and London: Duke University Press, 2019)

Morris, Rosalind, 'Drawing the Line at a Tree-Search: The New Landscapes of William Kentridge', in Rosalind Krauss (ed.), *William Kentridge: October Files 21* (Cambridge, MA and London: MIT Press, 2017), pp 113–46

Morris, Rosalind, *That Which Is Not Drawn: William Kentridge and Rosalind C. Morris Conversations* (Calcutta, London, New York: Seagull Books), 2014

Osborne, Peter, *Anywhere Or Not At All: Philosophy of Contemporary Art* (London: Verso, 2013)

Rebentisch, Juliane, *Aesthetics of Installation Art* (Berlin: Sternberg Press, 2012)

Rebentisch, Juliane, *Theorien der Gegenwartskunst* (Hamburg: Junius Verlag, 2013)

Richard, Nelly, *Eruptions of Memory* (Cambridge: Polity Press, 2019)

Rothberg, Michael, *Multidirectional Memory: Remembering the Holocaust in the Age of Decolonization* (Stanford, CA: Stanford University Press, 2009)

Rubinstein, Raphael, *Guillermo Kuitca* (London: Lund Humphries, 2020)

Sodaro, Amy, *Exhibiting Atrocity: Memorial Museums and the Politics of Past Violence* (New Brunswick, NJ: Rutgers University Press, 2018)

Speranza, Graciela, *Guillermo Kuitca: Obras 1982–1998. Conversaciones con Graciela Speranza* (Buenos Aires: Grupo Editorial Norma, 1998)

van Alphen, Ernst, *Caught by History: Holocaust Effects in Contemporary Art, Literature, and Theory* (Stanford, CA: Stanford University Press, 1998)

Young, James E., *The Texture of Memory: Holocaust Memorials and Meaning* (New Haven, CT and London: Yale University Press, 1993)

Image credits

1 © Guillermo Kuitca; 2 © Guillermo Kuitca; 3 © Guillermo Kuitca;
4 Photograph: Herbert Lotz, © Doris Salcedo; 5 © Doris Salcedo; 6 © Vivan
Sundaram; 7 © Vivan Sundaram; 8 © Doris Salcedo; 9 © Doris Salcedo;
10 Photograph: Sergio Clavijo, © Doris Salcedo; 11 Photograph: Laurie Cearley,
Courtesy the artist; 12 © Nalini Malani; 13 © Nalini Malani; 14 Tate, Courtesy
the artist; 15 Tate, Courtesy the artist; 16 Courtesy the artist; 17 © Doris
Salcedo; 18 © Vivan Sundaram; 19 © Vivan Sundaram; 20 © Doris Salcedo;
21 © Vivan Sundaram; 22 © Alfredo Jaar. Archivo MMDH; 23 © Alfredo Jaar.
Karinna Suter, Archivo MMDH; 24 Photograph: Juan Fernando Castro,
© Doris Salcedo; 25 © Doris Salcedo.

Index